WES KRONINGER'S

LIGHTING

DESIGN TECHNIQUES
FOR DIGITAL
PHOTOGRAPHERS

D1456389

AMHERST MEDIA, INC. ■ BUFFALO, NY

ACKNOWLEDGMENTS

Thanks must go first to my wife Missy for being an amazing source of support and guidance through the process of writing this book. The next thank you goes to my clients: without your professional trust in allowing me to make a majority of these images for you, this book would never exist. Also, last but not least, thanks go out to all of my colleagues and fellow photographers who remain passionate about our trade and keep me excited about the future.

Lighting diagrams by Trevor Lemoine.

Published by:
Amherst Media, Inc.
P.O. Box 586
Buffalo, N.Y. 14226
Fax: 716-874-4508
www.AmherstMedia.com

Publisher: Craig Alesse
Senior Editor/Production Manager: Michelle Perkins
Assistant Editor: Barbara A. Lynch-Johnt
Editorial Assistance from: Chris Gallant, Sally Jarzab, John S. Loder

ISBN-13: 978-1-60895-254-0
Library of Congress Control Number: 2010904515
Printed in Korea.
10 9 8 7 6 5 4 3 2 1

Check out Amherst Media's blogs at: http://portrait-photographer.blogspot.com/
http://weddingphotographer-amherstmedia.blogspot.com/

TABLE OF CONTENTS

ABOUT THE AUTHOR

Wes Kroninger is a photographer and educator in Long Beach, California. Wes is known for his inventive editorial and beauty portraiture, cleanly lit images with a vitality and vibrancy that impact viewers immediately. Wes's work has appeared in numerous publications including *American Salon, Modern Salon, Rangefinder,* and *Rolling Stone*. His career has taken him around the United States photographing award-winning projects for a range of clients. In the photography industry, Kroninger has also been recognized for his work as an instructor, leading an extremely successful platform class at the 2009 WPPI convention in Las Vegas, where he shared some of the secrets of his elegantly lit beauty images. He is also a contributor to Pro Photo Resource, a popular on-line resource for amateur and professional photographers.

In my experiences while speaking at photography workshops around the United States, I realized that consistent lighting was the number-one technical issue that troubled those attending. While lighting is the most fundamental aspect of photography, effectively capturing it or creating it with intent is one of the hardest things to do. The complexity of f-stops and lighting ratios seems to paralyze many photographers, while others overcomplicate the process by getting hung up on the amount of tools that are available. It can be much less challenging to create beautiful work when your lighting is approached in a simple, deliberate, and thought-out way.

My photographic style is a bit surreal at times; I rarely find a scene where I am not inclined to modify the lighting in some way. Whether it is with a simple reflector or a more complicated setup, I personally tend to lean towards artificial light, only because it usually completes the previsualized image I have in mind. In my opinion, even photographers who use primarily "natural" light often take advantage of the fill created by a white wall or the subtle reflections from water. Because of this, I find that every photographer could benefit from a strong understanding of light—what to expect from it and how to control it.

ABOUT THIS BOOK

My goal with this book is to show that photographic lighting can be as easy or difficult as you make it. Whether your photography is created for a commercial advertising client or fine-art portraiture, the key is beautiful lighting. That, in tandem with other visual elements, will please your clients and pull viewers into the image. As you read this book, I hope that some of the mystery around lighting for beauty and portrait images will be eliminated—and that you will see the simplicity in specific lighting elements and be inspired to experiment.

Additionally, I hope to demonstrate that when educated decisions are made in the proper order regarding the selection of tools needed, the job preparation can be less stressful. By handling your project planning as a series of specific decisions, you can make sure all of the pieces of the puzzle fit together. This preparation will help you to create great images. But the first step in preparing for any job is to understand the scope of the project as well as what the intended goals are. This book will walk you through the steps I use to make lighting decisions, but it will also give you tips on ways to anticipate what to expect from certain types of light in order to make your own decisions.

Finally, I want to show that lighting styles can be used for *any* purpose, regardless of the preconceived photographic determination of the image's use. The line in the sand between lighting styles has been washed away; the same lighting used for a beauty image is now fair game in a portrait session and vice versa. There has never been a better time to experiment and push the envelope.

HOW THIS BOOK SHOULD BE USED

A person cannot memorize individual lighting concepts from a book and expect to have success with this knowledge without having experimented beforehand. My hope is that this book will serve as a reference guide for inspiration and guidance, explain the importance of light testing, and also draw up a road map of the creative process.

The lighting diagrams in this book will *not* show you specific ratios or the intensity of each light. This is because a range of factors in your own photography session will determine how each light needs to be placed and recorded. I feel strongly that after your main light is set, additional light sources should only be added on an as-needed basis to solve a problem or add emphasis. For this reason I have left room for modification and interpretation in these setups.

LIGHTING TOOLS AND TECHNIQUES

Photographic lighting is best learned by trial and error. Learning lighting basics is very important, but because so many individual factors are at play in each project that a photographer undertakes, it is important to understand more nuanced lighting properties as well.

1. PHOTOGRAPHIC LIGHTING

Expressing a subject's mood and emotion has been the goal of artists since they first began depicting people in their works. Lighting is one of the most powerful tools an artist has to represent feelings and personality, and it is *everything* in an image—because composition, pose, and tones don't exist without it. That is why learning how to anticipate the effects of light is important, not only to define the mood of an image through color and intensity, but also to give descriptive visual clues about texture and shape.

To that end, it can be said that lighting is important to all artists, but for a photographer it is the only way to tell the story. Like paint to a painter, light is used by photographers to create an image on a blank canvas. Unlike painters, however, photographers lack the luxury of being able to merely envision what it is they want to create. Light falling onto film or a digital sensor is what transforms a photographer's vision into something that others can see and react to. Because of this, photographers and videographers are the only artists who require light to be physically present in the scenes they wish to capture. They, arguably more than any other artists, are expected to have a strong understanding of light, because if the light they need does not exist they have to create it. Even if it does exist, they will have to anticipate just the right moment or try to manipulate it to get exactly what they want from it. For these reasons, lighting should be a photographer's first concern when considering an image or preparing for an assignment.

Understanding how the properties of light affect a subject makes it possible to create images for a range of purposes and a multitude of clients. Each job niche in photography has a specific photographic goal and most can be defined by the type or style of lighting needed to achieve this goal. For example, if the work is being created for the conventional portrait customer, the aim of the photographer is to create an image that captures the personality and uniqueness of the subject. Historically, portrait photographers preferred soft light because it is flattering for the broadest range of people. If, on the other hand, the work will be used in advertising, there will be a clear set of client requests that need to be achieved to express whatever is being marketed. Generally, edgier light is used to catch the eye and draw attention to the product or subject in an ad. Images shot for magazine clients need to walk the line between being flattering depictions of the subject and being eye-catching enough to get readers to grab the publication off the shelves. This has often meant the implementation of high-contrast, experimental lighting, or the use of conceptualized sets or props. Fine-art portraits have to strike a balance between lighting, composition, and pose with an outcome that creates work with strong emotion. Great fine-art portraiture has a unique way of using subtle lighting cues to conjure a response in its viewers.

Lighting is important to all artists, but for a photographer it is the only way to tell their story.

Commercial and editorial photographers, to some extent, have had the freedom to push the boundaries of the lighting styles for decades—but, for a time, consumer portrait photographers were somewhat trapped in a world of cookie-cutter image production. The advent of digital photography made creating professional-quality images more accessible and opened the door for a new crop of budding professional photographers. As these new artists began to push the boundaries of what was the status quo, lighting techniques that were mainly reserved for commercial and editorial applications began to make their way into the consumer portrait world. As consumers become more aware of photographic styles, and as portrait photography itself continues to evolve, it will become

increasingly more common for the lines to blur between commercial and portrait image styles.

This melding of styles makes it clear that it is now more important than ever for photographers to be flexible and comfortable with their lighting techniques. Taking the time to learn about lighting can make you more competitive in today's photography market.

LEARNING FROM THE LIGHT AROUND YOU

No matter the genre of photography, knowing how to measure and capture light is critical for photographers. Equally important, however, is learning to control and anticipate its effects. One of the best ways to do this is by observing the light that is present in your everyday surroundings. When we light a subject or a scene, we are ultimately mimicking the natural world. Combining elements of light that would not naturally coexist can create surreal images—but to do that, you must first have an understanding of the effects of light.

Understanding that light is always present is important. It is not always perfect, it is not always white, but it is *there*—and paying attention to it can help you design the look of your photographs. Sometimes, we blend our lights to the point that it looks so natural it is hard to tell that it is artificial. Other times, we want our work to have an illustrative, graphic appearance that requires lighting unlike anything we have seen before. Paying attention to the world can help us to mimic what we have seen or create a lighting style that we have not seen.

Whether working in the studio or on location, the goal is to create images that have emotion. The beauty of light often lies in its simplicity and its imperfections. Just as musicians have only twelve notes with which to create the limitless emotional possibilities we hear in music, photographers have only a limited number of tools at their disposal. Yet, given this small set of lighting tools and techniques, photographers are able to express a wide range of feelings.

When you think about your favorite scene in a movie or a fond, vivid memory, it is easy to recall the emotions connected to these memories—and chances are lighting played a role in those feelings. When noticing the light around you, try to see not only how it affects the direct visual qualities of what it is illuminating (like the texture

With a small set of lighting tools and techniques, photographers are able to express a wide range of feelings.

of the surface material) but also the emotion it conjures. Imagine the cool blue glow of winter dusk, a saturated orange summer sunrise, the subtle flickering glow from a fireplace, or the tense red flash of a police siren. Merely reading those words and visualizing them in your mind most likely conjures up a mood or emotional reaction.

When we apply what is learned from observing the light present in the real world to the situations surrounding our photography, decision-making becomes intuitive. Testing the lighting equipment available also helps us to make the

connection between the look we are after and the types of light each tool can create. This testing can make problem-solving before and during a shoot a part of the process rather than an obstacle in your way.

DEFINING STYLE AND USE

The specific use of a photograph can often predetermine the lighting that will be used. Because of this, many photographic tools are used in specific genres of photography. For this reason, we often find ourselves using the same techniques and equipment repeatedly because they consistently achieve goals that need to be met. While this is okay, breaking these norms and trying new techniques is what fuels further creativity and pushes the photographic industry forward.

Trying new techniques is what fuels further creativity and pushes the photographic industry forward.

Portrait Photography. Portrait photography spans everything from corporate, editorial, and advertising markets to consumer-based portrait photography. Even though the final usage is different, the goal of each photographer is usually the same: capturing the presence of a subject through visual clues that represent their personality and making a connection with the viewer.

With a younger breed of photographer challenging the status quo, consumer-based portraits have now become extremely stylized. As a result, today's photography buyers have a plethora of styles and artistic approaches to choose from.

It can be hard to get noticed by prospective clients, but one thing that can give a photographer an edge is a strong understanding of lighting and consistent success with it. Whether natural or artificial light is used, the ability to consistently capture beautiful lighting is one major area that draws a line in the sand between a photographer who occasionally gets lucky and one who delivers what is required every time.

Traditionally, lighting for portraits meant maintaining the simplest lighting scenario possible, capturing a representation of the person being photographed while not drawing attention to the lighting itself. While this still has its merits—and you will see a lot of the lighting in this book is done with a one-light setup—the door is open to experiment and step outside of the box.

Beauty Photography. Beauty photography is designed to meet the photographic needs of the beauty industry; therefore, it encompasses a set of techniques designed to yield results preferable for advertising beauty products. These lighting styles were, in some ways, borrowed from the classic glamour portraits of the 1940s and '50s. In a sense, it has become a niche of photography created for an industry, by an industry. However, as beauty lighting styles became more popular, they began to be seen in all realms of people photography.

I have always thought about beauty photography as being like product photography: what is being photographed is a tangible product . . . it just so happens that the products are on the models. The clients range from salons to product manufacturers, but most are actually selling the same types of products. A hair product may boast shine or increased volume. Some makeup products claim to reduce skin texture, while others offer vibrant colors. As a photographer, your job is to figure out how to get each of these qualities to "read" in a photograph. That is where understanding the strengths of each available photographic lighting tool comes into play.

Lighting for beauty photography is unique because the intent is to bring out the textures and definition that help to visually describe a product while at the same time retaining qualities of light that are flattering to the model. Hard light sources help define and sharpen details. This is great for a product but can accentuate flaws on a person's skin. Conversely, soft lights are great for the complexion but they do not yield the contrast needed to accentuate textures and colors. Because of these contradictory requirements, unique lighting tools are often used in beauty work. These include large hard light sources (like giant umbrellas) and smaller hard lights that are meant to be used close to a subject, increasing the apparent size of the source (like beauty dishes).

2. PREPRODUCTION

PLANNING FOR YOUR PROJECT

I have often heard that preproduction is ninety percent of a photo shoot. Whether a project is a personal shoot for your own portfolio or a commissioned assignment, careful preparation is imperative to guaranteeing a successful outcome. In addition to making your project run smoothly, the preproduction work will help you successfully customize your client's experience and visualize what you are trying to accomplish. No two jobs are exactly the same. By listening to your client's needs and

The preproduction work will help you successfully customize your client's experience and visualize what you are trying to accomplish.

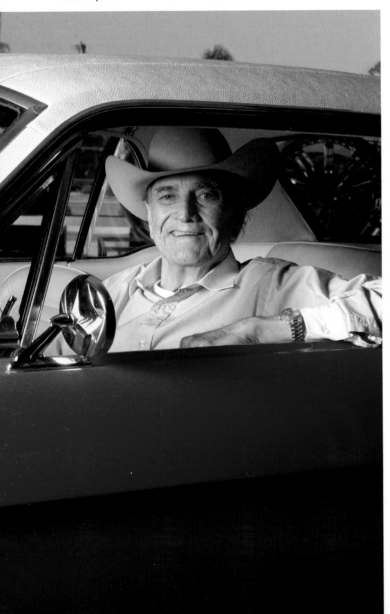

delivering what they are after, you will create something fresh that is one of a kind.

The planning process can seem daunting. If, however, it is approached with a clear list of questions that need to be answered, prepping for a project can be easy and enjoyable. For large projects, a production company is often used to handle all of the logistics as well as the crew member hiring, but for most photographers, these matters have to be handled personally or by an assistant. For this reason, it is a good idea to make the process repeatable and fine-tuned.

DEFINING THE SCOPE OF A PROJECT

A project's usage, budget, and time frame all have ways of steering a production in either a more complex or more simplified direction. For example, if the budget is limited or a very limited time frame has been allotted for a project, then complicated lighting sets are generally ruled out automatically. Therefore, it is a good idea to get a handle on the details of a shoot before other creative decisions are made. If the project is for personal work, then you will already know all of these answers. If it is a commissioned assignment, you will have to ask the appropriate questions to make sure future decisions are not made in vain.

BUILDING YOUR TEAM

When a clear picture of the size of a project begins to materialize, it is safe to start building a team of people to help in the creation process. The stylists and other creatives on set during a project are important to the overall success. Everyone involved can bring something to the table to make each project unique—but choosing the right people to fill these roles can be critical.

Assistants. Hiring a capable assistant can be the best thing you do to ease some of the pressures of the job. There is plenty to worry about on the day of an assignment, and an assistant can take a huge weight off your shoulders, enabling you to focus on the main job: creating great images and satisfying your client's needs.

Hiring an assistant can be an easy process if you know where to look—and most assistants are as passionate about the success of your job as you are. Professional photography organizations or crew and stylist database sites are a great way to find someone in your area or, if you are traveling, in the city where you will be working. Hiring an assistant while traveling can save money on travel costs, but it can also be a bit risky working with someone for the first time. Asking for references is acceptable to ensure professionalism.

Stylists. Stylists are very important and their roles are ever-changing—from wardrobe, hair, and makeup styling, to prop and location styling. Generally, when and how many stylists can be used on a project is a matter of budget—and it is often up to the photographer to pitch this sale to the client. Expressing the importance of a stylist team can sometimes be a tough sell to a budget-conscious client, but it is always best to have them on set—not only for their fashion sense and ability to pull off a "style" that the client is after, but also so that the photographer can focus on their own role in the production.

Finding the right stylist for a job can take some patience, but it is worth holding out until the correct person is found. In a small market, it can be difficult to find a wardrobe stylist or even a hair or makeup stylist who has worked on a photographic production. Again, the internet is a valuable resource for searching out the right stylist for a project. There are a wide range of sites with stylist databases, including portfolios and bios that make finding the right fit for your brand of photography easier than ever. It is a good idea to get references and be sure to see a portfolio before hiring someone for a project. Remember: the success of the creative team often sits on the shoulders of the photographer who hires them, so if they do not have references, the best bet is to meet them in person prior to a shoot to make sure they are professional enough to help the project along.

STORYBOARDS

A photographic direction needs to be determined and communicated to all of the creative team to confirm that everyone is on the same page. One way to do this is by the use of a storyboard. A storyboard is a set of images pulled from magazines or books as reference for direction and

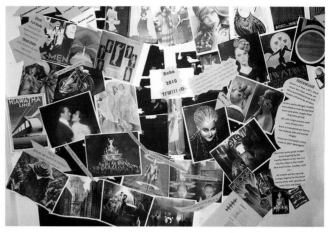

In this photograph, Dennis Clendennen (owner of Dionysus Hair/Salon and Spa) has created a storyboard describing his intent for an upcoming photo shoot. Photograph by Dennis Clendennen.

creative intent. Storyboards are traditionally used in the film industry as a way to keep plot lines in order, but for the still photographer they provide a way to clearly convey image concepts. Clients, photographers, and stylists often speak different creative "languages," so it is best to use images to illustrate how each member intends to produce the look desired.

The use of storyboards can also avoid problematic situations even before shooting begins. There may be certain things that a client wants to avoid or would like to see. Visually representing your idea can allow the art director to previsualize the final outcome in the same way you, as the artist, can. It is also very valuable for photographers to be able to see whether or not they anticipate any issues with lighting as it relates to the makeup and hair styling.

LOCATION SCOUTING

If a shoot is to take place on location, scouting is a sure-fire way to minimize surprises on the day of production. Simple location scouting has saved many photo shoots. Location scouting can include dealing with property owners to make sure it is okay to shoot there; this is also known as "clearing the location." Scouting should also include checking for everything that you would need throughout the shoot, including ample power, access to restrooms, security, etc. It is best to work from a list so that nothing is overlooked.

Sketches and Equipment Lists

While it is good to have a master checklist of gear (for small items, like memory cards, lenses, tripods, etc.), I find it is also useful to sketch out your actual set, specific to each project. While preparing for an assignment, it helps to mentally "walk" the set, making sure everything you need will be on hand. Start out by sketching all of the main components, like the main lights you intend to use, the backgrounds, and the cameras. Then move to the details, such as Pocket Wizards and a laptop. From this point, you can make a checklist of the gear needed.

Sketching out your actual set makes it easier to ensure that everything you need will be on hand.

If You Don't Have It, Rent It

Just because you do not own a needed piece of equipment does not mean it has to be ruled out. Renting equipment is a viable option. Depending on the equipment needed, the fees are often minimal enough that it is an easy sell to a client—especially if they feel the expense is in their best interest. This is another piece in the puzzle of creating a custom experience for the client. If the goal the client is trying to meet requires specialized equipment, it is in their best interest to enable the photographer to be successful and not just try to make do with whatever equipment is on hand.

The accessibility of photographic rental companies and the ability to have equipment shipped has made it much easier to get equipment in locations lacking rental houses. Many companies can be found online that can ship equipment to almost any location. The downside of this is shipping fees, so the cost of shipping needs to be factored into your budget.

If you are traveling, you can sometimes find a local photographer who is willing to rent equipment. One way to do this is to contact the local American Society of Media Photographers (ASMP) or the Professional Photographers of America (PPA) chapter where you will be traveling. Ask them if any photographers in the area rent equipment. These professional organizations can be great point contacts and can quickly help you find the tools you need.

3. LIGHTING DECISIONS

THE TOOLS OF THE TRADE

There are numerous lighting tools available to assist a photographer in realizing their artistic visions. Despite these many options, however, it is important to remember that there are a limited list of qualities of light that are being created by each tool. Just as musicians have only twelve notes to create the music we hear, photographers have only three lighting qualities with which to work. These three lighting qualities are the *intensity* of the light source, the amount of *diffusion* used, and the *angle* at which the light strikes a surface. (*Note:* Color is another factor, but because it is an indirect quality, we will not touch on it here.) These three characteristics are everything that a photographer needs to create images. Each lighting source produces differing levels of all three qualities, creating unique combinations.

DECISIONS ON LIGHTING

The Size of the Light. Because the amount of diffusion, or the effective size of the light, plays such a critical role in light quality, the most important decision that needs to be made is generally the size of the main light source. The size of a light can actually affect the other two qualities in significant ways. First, the size of a light can affect intensity by focusing the power of a light into a very small space or by spreading it out over a large area. Small, focused spots of light will be more intense than the same power of light greatly dispersed or blocked by layers of diffusion material. Also because a larger light tends to "wrap" a subject more, it creates a flatter image with less contrast at nearly all angles from the subject. It is very hard to achieve a high-contrast image with an extremely large light source. For these reasons, determining whether to use a hard light (small source) or a soft light (large source) should be your first decision.

The Intensity of the Light. The second decision that is made is the intensity a light will have and the attention it will warrant. When working with one light, a blending or balancing of flash and ambient light is often used. This blending of two light sources is where the intensity factor of our light source can play a major role in what can be achieved. Understanding that shutter speed has no effect on flash exposure (as long as we stay below our flash-sync speed), we can use the shutter speed of our cameras to blend our flash and ambient light, creating differing amounts of emphasis in our images. Using this strategy, you can underexpose the ambient light by increasing shutter speed and making the subject of the image "pop," demanding attention by letting the strobe make your subject the brightest part of the frame. Alternately, you could balance the flash and ambient light to equal exposure levels for a more natural, even effect. You could even set the flash to be underexposed in comparison to the background, creating a subtle silhouetted effect.

Each person's face shape and skin texture should be approached on an individual basis . . .

The Direction of the Light. The direction of the light is the last decision to be made—and it is what has the most effect on the surface texture, drama, and mood of an image. This is best adjusted once the model is on set. Each person's face shape and skin texture should be approached on an individual basis, so moving the light around to the most flattering position for them is critical. Once we have achieved the desired contrast ratio by balancing our light sources, we adjust the light along an imaginary arc around the subject (keeping the distance between the light and the subject constant means there is no need to adjust exposure). By moving the light along this arc, the shadow areas in the image can be refined. To create a more modeled look, move the light farther to the side of a subject; for a flatter look, bring the light closer

to the camera axis. Changing the elevation of the light will also alter the lighting by elongating the shadows on a vertical axis. Moving it overhead can create a butterfly or glamour lighting pattern; lowering it below the model's chin yields a ghoulish look that is mostly avoided.

TESTING = PREPARING

It is easy to get lucky every now and then, but a client will be looking for a photographer who is consistent. With such an emphasis put on lighting, and the importance of understanding its effects, testing lighting setups and different modifiers is critical to remaining ahead of the game. Major league baseball player Brooks Robinson once said, "If you're not practicing, somebody else is, somewhere—and he'll be ready to take your job." And this is truer than you know.

No one ever learned anything by not failing, but the last thing anyone wants to do is fail while on the job. It is important to schedule time to learn. Schedule yourself sessions where there are no expectations of an outcome and the only goal is to test concepts you may have been curious about. Keep notes of things you see in your day-to-day life and try to recreate them. Rent and try out a new modifier. Borrow a piece of equipment from a fellow photographer and give it a try, or just try some new things with your current gear.

When you are being paid and other people's time is invested in a shoot, you should never use an unfamiliar piece of equipment. This will not only add stress to your situation, it can also compromise the confidence your client and team put in you. If you are fumbling around with equipment during a shoot—or, worse yet, fail to create the quality of images expected of you—that client will most likely never work with you again.

STRINGING THE LIGHT

Some photographers use a piece of string to ensure that they or their assistants do not inadvertently move the light closer to their model while making slight adjustments to the light direction. Each time the light is moved, a string attached to the light is outstretched to recheck the distance from the model.

MEASURING THE LIGHT

Discussions are raging on photography message boards and forums regarding the need for handheld flash meters in the digital photography age. New digital cameras have taken through-the-lens (TTL) metering to another level by offering histograms and over- and underexposure warnings, but to rely on these alone is dangerous. While these in-camera tools are great for ambient readings on the fly, I do not feel they are ideal for critical flash photography. Light can be fleeting, mysterious, and ever-changing, so it is best to use every tool available to achieve proper exposure.

One of the downfalls of in-camera metering is that you are limited to reflective readings. This means you can only read the light that reflects off of your subject or scene. Because of this, it is possible to get erroneous results in extreme situations—like backlit scenes or subjects in strong side lighting. Also, the spot metering capabilities of most cameras are less refined than those of handheld units. The handheld units can provide very precise results by measuring as little as 1 percent of the image area.

Flash-reading capabilities are another great reason to use a handheld unit. Being able to measure the quick burst of the strobes, in either spot (reflective) or incident modes, lets you know exactly what lights are doing even before the first frame is snapped. At this point, histograms and other tools can be used to fine-tune exposures and reposition lights if needed, but in my opinion a light meter should be an integral part of a photographer's process.

THE BALANCING ACT

Not all light is created equal—especially when it comes to color. When film is used, a color meter is used to give a color temperature reading. Then, with this reading, filters can be used to balance the light entering the lens to match the specific film being used. With modern digital cameras, color can be balanced in-camera, making it simple to fine-tune the color balance for each specific shot—and even each time a light's power setting has been changed.

While there are many techniques and tools available to ensure optimal color balance, I find the simplest approach is to balance in-camera while on set, but also to capture in RAW mode and record a reference chart. The chart can be a grey or white card—or, for further accuracy,

something similar to a Macbeth ColorChecker chart can be employed. This chart can then be used to fine-tune the color when processing your digital files.

Color balancing should be a part of every photographer's workflow to ensure accurate color and neutral whites. Because strobes can shift color temperature at different output power settings, when feasible I capture a new reference image each time I drastically adjust the power settings up or down. Making this part of your capture workflow is an easy step that can have a huge impact on your final image.

TETHERED CAPTURE

Tethered capture enables photographers to transmit image data to a desktop or laptop computer via a USB or FireWire cable, rather than recording the image data to a CompactFlash card. Once on set, tethered capture is an integral part of my photo shoot preparation because I feel it gives me the most accurate view of my images.

Using the computer monitor during the preproduction stages, when lights are being set and fine-tuned, turns the computer monitor into a "digital Polaroid." The clarity and data provided by the on-screen image helps to visualize exposure and lighting direction, and also allows stylists and other team members to see (and, if necessary, refine) their work. Using the larger computer screen, rather than the small display on the back of the camera, makes it easier to correct any issues *before* the final shot is captured. I find this gives me a greater sense of confidence while I am working.

Once the lights are set, the camera can be unplugged from the computer and images can be captured to a memory card. I do this occasionally if I need freedom of movement or if I feel the photo shoot itself will be hurt by the pauses in action that often result from on-set viewing. The disadvantage, though, is that it is more difficult to see any inadvertent changes to camera exposure or if a light has been accidentally moved.

Another approach is to use tethered capture throughout the entire session, allowing each image to appear live on screen. This has advantages and disadvantages. One advantage of shooting tethered is that it enables the images to be constantly monitored by your assistants. Also, your image data is immediately backed up to a more stable platform than the CompactFlash card. Another advantage is for the stylist team; they can continue monitoring for any wardrobe or makeup problems that may occur during shooting. This can result in quick fixes that could save hours of postproduction and editing. This ability to view results in real time has revolutionized the way creative teams interact on set.

Unfortunately, in some instances, slow data transfer rates between the camera and computer can slow down the flow of a shoot. In the worst case scenario, if the transfer rate is too slow from the camera to computer, the internal buffer of the camera can be exceeded. At that point, no more images can be captured until the data has been written. This stops image capture dead in its tracks.

While tethered capture has its merits during projects where many people are involved, I do not recommend tethered capture when working with non-professionals in a one-on-one session, like a portrait sitting. For portrait subjects, seeing their image appear on the screen each time a frame is captured tends to be distracting. This makes it much more difficult to get your subject to relax and be natural.

LIGHTING OPTIONS FOR LOCATION PHOTOGRAPHY

Selecting lighting equipment that is lightweight and easy to manage is a good bet for indoor or outdoor location photography.

Working Unplugged. Sometimes it is nice to leave all the heavy gear at the studio and work with only a reflector, maybe a scrim, and the available light as it falls. It can be liberating, and it reduces the technical headaches that can arise from using flash or strobes. The concepts that you will use during a session using just a reflector are the same ones in use when you are using studio lighting—although the translation can feel more organic and fluid.

Reflectors are a great way for beginners to learn the basics of lighting. When I started shooting, I had a piece of hard board insulation that came with a gold reflective surface on one side and I used strips of duct tape to create a silver side. I got a lot of mileage out of that one board.

The major benefit of lighting with a reflector is that what you see is what you get; there are no surprises. A hand-held reflector can be moved fluidly and the results

can be seen easily, simplifying the entire process. Another plus is their size and weight. Even reflectors that aren't the pop-out kind are lightweight enough that they can be easily carried from one location to the next.

A downside to using a reflector can be the overall intensity of the light. Silver and gold reflectors made out of a shiny material can pack a lot of power. It is difficult for models not to squint when the full force of the sun is being directed back at them—and the light can be extremely warm on hot summer days. One option is to feather the light slightly off your model (so they aren't being directly hit by it). Alternately, you could switch to a white version, which is less reflective. Sometimes, though, neither of these choices will provide the amount of light needed to match the background brightness. In this case, the best option is to use the reflector off axis just enough to eliminate squinting and to give your model breaks, taking the light off of them periodically so they can cool down and rest their eyes.

Personally, I feel that when I need to travel light the benefits of using a reflector as a main light far outweigh any downsides. I have never run into a situation where I was unable to get the shot using the techniques I mentioned. I prefer to work with a reflector during outdoor portrait sessions because I frequently work without an assistant. The simplicity of a reflector's design makes it possible to have a friend or parent who is present at the shoot hold the reflector, or for it to be easily attached to a stand. *In section 2, see images 1–4 for examples of working unplugged.*

Monohead Lights. On locations where power is available, monohead lights are an option. They do not have a power pack and the power and cooling fan are housed inside the light itself, allowing for independent control of each head. This eliminates the need for cables running across your set. The downside to these lights is that a power source needs to be nearby—and that is not always the case. Running extension cords a long distance

BATTERY POWER

When using a small light, AAA battery life can be drained quickly. I recommend an external battery. This will extend the number of bursts that can be achieved before the batteries are exhausted.

is dangerous and just as cumbersome as using a pack. Also, these heads sit a bit heavier on a light stand. Because of this, they are top-heavy and more likely to topple over.

Battery-Powered Strobe Packs. Where power is not available, many photographers choose battery-powered strobe packs, since the pack itself contains a rechargeable battery that supplies the power needed. These lights have now become more reliable, lighter, and able to produce light comparable to high-end studio strobes. The plus to battery-powered strobes is that they can output substantial power anywhere you need it. The downside is price; the higher-end versions of these lights—the ones that boast low weights and consistent lighting—can be outside of the budget of many photographers. Most rental houses rent these packs, however, so if battery-powered lighting seems like a good choice for a project, renting is a very viable option.

Electronic Flash. Small flash units can be a great choice in many situations. Whether used in TTL or manual modes, the portability of these tools is unmatched. For years, wedding photographers and journalists have relied on small flash units to get the job done. As flash technology has improved, the use of these devices has increased.

Newer electronic flash units produced by camera manufacturers are capable of communicating with a camera body for fully automated control, and accessories are also available to allow the same functions with third-party products. To keep things simple (and avoid employing too many accessories), I tend to use these tools in manual mode. By placing a TTL flash on a light stand equipped with a slave unit, I can use the flash off-camera as I would any other strobe. These flashes can put out a surprising amount of power and produce an image that appears as though it was created using more expensive lighting gear. *In section 2, see images 5–10 for examples of working with electronic flash.*

THE STUDIO ON THE ROAD

Light Modifiers. Light modifiers, by design, block some of the light from a flash—or spread it out over a larger area, effectively reducing its output. Therefore, the lower power outputs of TTL flash devices limit the ways in which they can be modified and still be effective. Studio-style

strobes, however, offer greater power output. Because of this, light modifiers can be used while maintaining a workable amount of light. This makes them a great choice when a specific light quality or large light source is needed.

One Light. There is a tendency for photographers to throw as many lights as possible at an image, hoping that it will create interest. In reality, if the composition is strong, an appropriate lens choice has been made, and the correct light and modifier have been selected for the desired effect, one light is frequently all that is needed. Adding more lights when they are not needed will only result in confusing the visual message.

Not only can one light be appropriate for creating the look you are after, but using only one light may be necessary in some difficult shooting situations. For example, photographers working on editorial or corporate assignments on location are often expected to get results in either uncomfortably short time frames or in less than ample locations. No photographer likes to be confined to what feels like less than enough time to create images, but sometimes that's just the way it is. When photographers need to work quickly on set, metering and working with three and four lights just is not realistic. In these situations, understanding how to choose the correct gear and balance flash and available light can save a project.

Weather and space are other factors that can make it necessary to use a less complicated lighting setup. Even if the proper location scouting has been done, unforeseen environmental conditions can sneak up on you and cause problems. Any photographer who has had to battle fifteen-mile-per-hour winds while metering three lights and piling sandbags on stands to prevent them from toppling over can attest to that! Small shooting spaces can also dictate the amount of equipment that can be used. Often, it is impossible to use side or backlighting when cramped into a tiny room. *In section 2, see images 11–14 for examples of working with one light outdoors.*

Adding for Effect. When space and weather are in my favor, I will often opt for additional lights to add light to a background or create some edge light to emulate sunlight and separate subjects from busy backgrounds. *In section 2, see images 15–21 for examples of adding lights for a specific effect.*

STAYING INDOORS

Being in the studio allows for the most control over our surroundings and generally gives the most resources available. Although location work offers a level of adventure and often requires downright stamina it is sometimes nice to work within the air-conditioned confines of the studio.

One and Done. When I begin a studio assignment, the decisions have usually been made already regarding the type of main light I will be using. Depending on what I anticipate, I will set up other lights off set that can be used if needed. This ensures they will be on hand. I try to see how far I can get using the chosen main light alone. When I get to the point where I need something more than the one light can give me, I add a light. Often, though, the one light is enough for the entire session. *In section 2, see images 22–29 for examples of one-light images created indoors and in the studio.*

Adding with Intent. There are an unlimited amount of reasons in which additional lights may need to be added to an image. They are unlimited because each image and each client requires different considerations. Light testing pays off each time I am asked by a client to solve a problem during a shoot. By knowing what tools to use to get the results I need, I can easily solve problems on set. *In section 2, see images 30–41 for examples of this approach.*

High Key. High-key lighting has been used for years to create images that have an upbeat, youthful look to them. There are many ways to produce a high-key effect even outdoors or in small spaces. *In section 2, see images 42–54 for examples of high-key lighting.*

Ring Flash. The popularity of the ring flash seems to fluctuate with time. Its shadow-free illumination is so unique that you either love it or hate it. The ring flash can be used in tandem with other lights or alone. However it is used, the effect the light source has on skin, fabric, and clothing detail is unmatched by any other light source. *In section 2, see images 55–58 for examples of working with ring flash.*

4. The Intangibles

Interaction Between the Photographer and Model

Whether a photograph is printed in commercial advertisements or framed in a family home, capturing the personality of your subject goes beyond lighting, posing, and composition. An important part of photographing a person is the interaction between the person behind the camera and the person in front of it. This is not always an easy task when working with limited time frames and difficult subjects, but is crucial to getting an image that will represent the subject in a relaxed way or reflect the story you are trying to tell.

When an image is a commissioned portrait, this means breaking the ice and getting a person to be genuine. How you approach this will change for each person being photographed, but a sincere interest in your subject's life can be the best place to start. A simple conversation during the session is usually enough to calm tensions and to get your subject to relax. When an image is for commercial use and a predetermined feeling or emotion is needed, it can be a bit more difficult to draw out the specific look you are after. Working with professional models is a great start in assuring success, but it can still require a certain amount of guidance from the photographer.

Interaction and model guidance can take a while to master, so it is best to take your time and practice. One way to practice is by photographing strangers. This will help you get used to striking up a conversation with someone you don't know. Look for ways to find common ground with your subject, regardless of age, race, or gender. And remember: the less nervous you are, the less nervous your subject will be.

An important part of photographing a person is the interaction between the person behind the camera and the person in front of it.

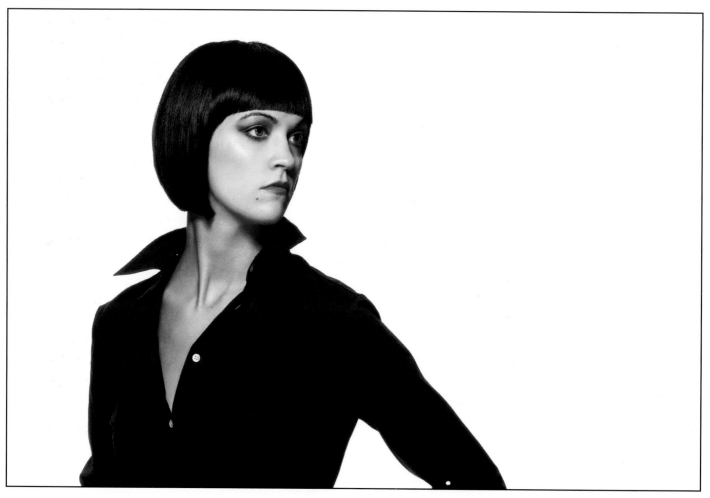

Another way to get experience is to work with people on drawing out an specific emotion or feeling from them. Approach this exercise like a movie director working with an actor. Photographers have a tendency to feel silly doing this, but it is an important part of photographing people.

POSTPRODUCTION

There is no arguing that postproduction and retouching plays a major role in the process of creating today's images. Yet many people overlook the fact that postproduction has always played a major role in photography. The effects produced during developing, negative retouching, and printing with film were obviously done differently than they are today, but the results were very similar to those created using the latest digital image processing and retouching techniques.

Problems will happen, but it is how we manage these problems that matters.

In the days of film, in-camera techniques (combined with film selection, pushing and pulling film, and different cross-processing techniques) resulted in some of the same effects we see in Lightroom, Capture One and other raw image processing software today. Some of the programs have even gone as far as to add "film effects," aimed at reintroducing some of the looks familiar from photography's analog past.

Retouching artists were also used to smooth skin and remove blemishes—just as photographers do today in Photoshop. The retouching done by these artists was such a specialized trade that it was handled primarily by professional retouchers. Negatives were hand painted to achieve the desired effects—a difficult and very time-consuming process.

Today, numerous contract-based retouching companies still exist and are great resources for photographers who have the budget to use these services. Recently, companies have even begun to emerge that offer simple image-processing and retouching services for wedding and portrait photography studios.

That said, a large amount of image postproduction still tends to be handled by individual photographers or their in-house staff. Although this has led to more work for photographers, it has also led to a greater understanding of what is possible in the postproduction stage of image creation.

Organizations like the National Association of Photoshop Professionals (NAPP) are great resources for photographers who want to expand their computer editing skills. Numerous other online resources are also available.

MAKING "IT" WORK— DESPITE MURPHY'S LAW

Lets be realistic. Things are going to happen that are outside of our control. No matter how much we prepare or how large the production, there are enough factors involved that something will inevitably go wrong. Cameras will fail, batteries will die, the rental house will forget something critical that you did not have time to check before leaving for the job, or models will not show up on time.

Problems will happen, but it is how we *manage* these problems that matters. I had a discussion with an assistant after a shoot that went particularly badly. *We* both knew it, but at one point the assistant realized that, because of the way we handled the situation, the *client* had no idea that anything was wrong.

A lot of what you do as a photographer is making "it" work. Most of the time we do not know what "it" is going to be until "it" happens—but we will most definitely know when "it" occurs. This sounds comical, but anyone in the photographic profession knows that one thing they love about the job is the problem-solving. Whether the problem is an off-the-wall request from a client or a piece of broken gear, when these things come up, it comes down to the difference between knowing what to do and not.

If you have done enough testing and preparation and have a solid understanding of photographic principles, you can get through most of the challenges thrown your way.

5. TERMS TO KNOW

Available light. Available light (also called ambient light) is any natural or artificial light that is present without manipulation by the photographer or crew. It is the light that is already "available."

Barn doors.

Barn doors. Barn doors are metal flaps attached to a light source. These can be opened and closed to direct and change the shape of the light from the source.

Beauty dish. A beauty dish is a light modifier that produces soft shadows, but sharp, specular highlights. It is commonly used in beauty photography.

Boom. An adjustable metal arm attached to a stand used for getting lights or other equipment overhead.

Bounce reflector. A reflector is a tool used to change the direction of the light.

Color balance. Color balance is the process by which the color cast caused by different types of lighting in an image is adjusted to result in neutral white or grey points.

Diffuser. Any material placed in between a light source and a subject with the intent to soften or reduce its intensity is considered a diffuser.

Electronic flash. Electronic flashes are small light units with lower power outputs than studio strobes. These are generally powered by alkaline batteries and measured in guide numbers. Most are TTL capable.

Fill light. Fill light is any light that is used to reduce (or "open up") the shadow areas created by the main light. *Contrast with* Main light.

Flash duration. The flash duration indicates how long a single "pulse" from a flash unit lasts.

Fresnel.

Flash-sync speed. The flash-sync speed is the shortest shutter speed at which a flash photograph can be taken.

Fresnel. A Fresnel is a type of flat lens used to focus a spotlight. The term is used generically for spotlights equipped with this feature.

Gobo. Short for "go between," gobos are used to block light from spilling onto the camera lens or to selectively block light from hitting the subject.

10 degree grid.

Grid. A strobe attachment with a honeycomb pattern that creates a high-contrast spotlight effect. Grids come in different ranges, adding more or less contrast to a light source.

5 degree grid.

Hard light. Hard light sources produce a well-defined edge between the highlight and shadow areas. Hard light sources are small relative to the subject. *Contrast with* Soft light.

High key. High-key lighting aims to limit the contrast of an image by using lower lighting ratios. *Contrast with* Low key.

Incident meter reading. An incident meter reading measures the light falling onto an object or scene. *Contrast with* Reflective meter reading *and* Spot meter reading.

Light meter.

Light modifier. A light modifier is any piece of equipment designed to change the visual qualities of a light source.

Lighting ratio. The lighting ratio describes the exposure difference between the highlight side of the subject and the shadow side of the subject. High ratios produce high contrast; low ratios produce low contrast.

Low key. Low-key lighting results in more dramatic, high-contrast images by using higher lighting ratios. *Contrast with* High key.

Main light. The main light (or key light) is the light source that creates the primary pattern of light and shadow in an image. *Contrast with* Fill light.

Mixed lighting. Mixed lighting is light that emanates from different types of light sources with different color temperatures.

Monohead. Monoheads are self-contained strobe units that do not require the use of a power pack.

Octabank. Recognizable by their octagon shape, these light modifiers (like standard umbrellas) come in a direct shoot-through style as well as a bounce style.

Power pack. A power pack is a power source used with strobe heads. *See* Strobe head.

Reflective meter reading. A reflective meter reading measures the light bouncing off an object or scene. *Contrast with* Incident meter reading *and* Spot meter reading.

Rim light. A rim light (also called a kicker light) is used to highlight the edges of a subject.

Ring flash.

Ring flash. A ring flash is a circular strobe head that can be used around the lens of the camera, creating a unique "shadowless" light source.

Scrim. A scrim is a tool used to reduce the effect and strength of the sun when shooting outdoors.

Seamless. "Seamless" is the term used to describe wide roll paper used on a stand and cross bar to create a background without a wall-to-floor interface.

Slave. A slave is a device used to trigger flash units wirelessly. Radio slaves do this using a radio signal. Optical slaves cause a strobe to fire when triggered by a second flash unit.

Snoot. A snoot is a tapered reflector used on a flash head to create a very narrow beam of light.

Softbox

Softbox. A softbox is a square or rectangular light modifier that provides soft lighting effects that mimic window light. They are available in a range of sizes and shapes.

Soft light. Soft light sources produce light with a gradual transition between the highlight and shadow areas. Soft light sources are large relative to the subject. *Contrast with* Hard light.

Specular highlights. Specular highlights are extremely bright areas in a scene. These are created by a direct reflection from the sun or another light source (usually a hard light source).

Spot meter reading. A spot meter reading is a reflective reading taken from a very small percentage of a scene. *Contrast with* Reflective meter reading *and* Incident meter reading.

Umbrellas.

Strobe head. A strobe head is a light that is powered by a power pack and designed for high power output needs. These lights are measured in watt seconds. *See also* Power pack *and* Monohead.

Umbrella. Reflective umbrellas are light modifiers that increase the effective size of a light source by bouncing light off the reflective underside of the umbrella and back at the subject. Shoot-through umbrellas are similarly shaped but constructed of white fabric that allows light to pass through the umbrella directly onto the subject (much like a softbox).

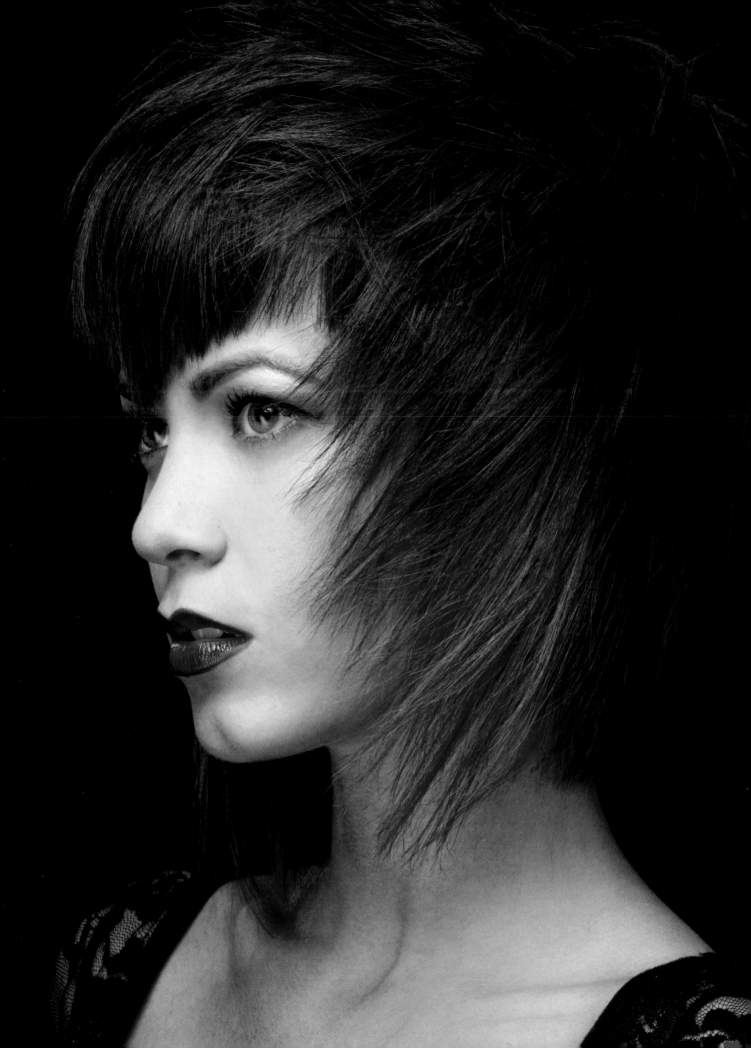

Lighting Design in Action

In this section, we will walk through a series of images starting from simple one-reflector concepts and moving into more complicated setups. I will do my best to describe to you why additional lights were added and also why only one light or a simple reflector was used. I have found that even when a solid understanding of lighting principles is achieved, elements outside of our control can often dictate the lighting we use. Whether it is budget, weather, space, time constraints, or client requests that guide how and why certain lighting is used, being able to meet these challenges with a clear understanding will help you succeed.

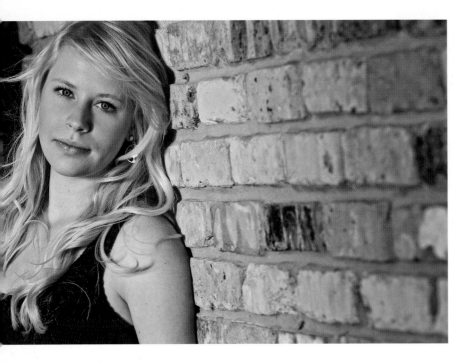

USE	Private commission
CAMERA	Nikon D2Xs
FORMAT	35mm digital
LENS	70–200mm f/2.8
FOCAL LENGTH	130mm
ISO	100
EXPOSURE	$^1/_{160}$ second at f/5.6
WHITE BALANCE	Custom
LOCATION	Baton Rouge, LA
TIME OF DAY	Late morning
LIGHTING	Available light with reflector

1 | THE SCOOP

Photographing high school seniors outdoors often creates a grueling schedule. When we want to get many poses in a short amount of time, it is often impossible to use any kind of strobes or electronic flash units. Fortunately, a simple reflector used properly can create beautiful light that seems as if it were created using studio equipment.

TECH

For this image, the model was positioned in the shade of a building. A 3x4-foot reflector was positioned in the direct sun, throwing light back into the open shade. This created a beautifully soft yet crisp light. The simplicity of lighting with a reflector makes it a good choice for photographing high-school seniors and children outdoors.

TIP

I chose to create this image with extremely horizontal formatting—and also selected an aperture setting that would result in a shallow depth of field. Doing this can effectively drop the foreground and background out of focus, drawing the eye to the part of the frame that is in focus, which contains my subject.

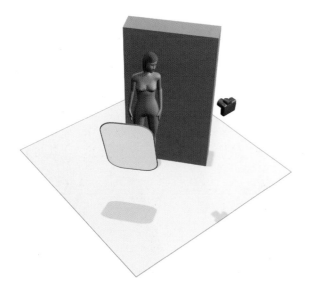

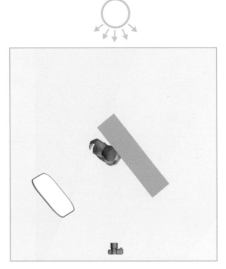

USE	Charity calendar
CAMERA	Nikon D2Xs
FORMAT	Digital
LENS	70–200mm f/2.8
FOCAL LENGTH	140mm
ISO	250
EXPOSURE	$^1/_{1250}$ second at f/4.5
WHITE BALANCE	Custom
LOCATION	Baton Rouge, LA
TIME OF DAY	Afternoon
LIGHTING	Silver reflector

2| THE SCOOP

When photographing children outdoors, it is best to keep equipment to a minimum. For this series, I wanted to achieve the appearance of a sunny spring day. I did this by using a single silver reflector.

TECH

To create this image, I used the shade from a large tree to get my model out of the direct sun. I had my assistant hold a single 2x3-foot reflector outside of the shade from the tree, bouncing the sunlight back at my subject. I used a long lens to get the background to appear extremely soft, making my subject pop from the background. I included negative space in my composition to leave room for the copy that would be included in the final layout.

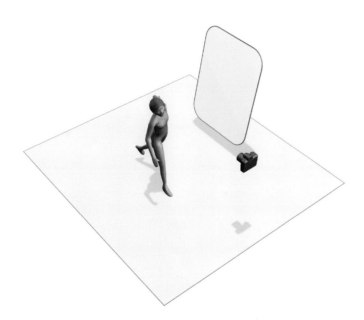

3 | THE SCOOP

This image was taken in direct overhead sunlight. This is generally best to avoid—but sometimes there are limited options as to when a session can take place.

TECH

To eliminate the unflattering shadows associated with the overhead sunlight, I used a four-foot square scrim that was just barely large enough to create shade for my model (you can see the area of shade created on the ground below her). A 3x4-foot silver reflector was used from her right to add a directional main light to the image.

TIP

Notice that this pose, while also looking relaxed, creates a triangular composition that leads the viewer's eyes back to my subject's face.

USE	Private commission
CAMERA	Nikon D2Xs
FORMAT	35mm digital
LENS	70–200 f/2.8
FOCAL LENGTH	80mm
ISO	100
EXPOSURE	$^1/_{200}$ second at f/5
WHITE BALANCE	Custom
LOCATION	Baton Rouge, LA
TIME OF DAY	Late morning
LIGHTING	Available light with reflector

4| THE SCOOP

In this image, the playground tunnel was used not only for its color contrast with my subject's sweater but also because it created the shade I needed to block the direct sun. I find that working outdoors during the early afternoon usually makes it necessary to block the ambient light so that more flattering lighting can be created. Overhead sunlight can result in dark shadows under the eyes.

TECH

A silver reflector was used at camera right to bounce a simple, soft light back into the frame.

TIP

As you can see here, I tend to crop in tight on my subjects. I feel that this makes the image more intimate by bringing the viewer in close. In this image, I used the shadows and specular highlights inside the tunnel to create lines that lead the eye through the image.

USE	Charity calendar
CAMERA	Nikon D2Xs
FORMAT	35mm digital
LENS	17–35mm f/2.8
FOCAL LENGTH	17mm
ISO	100
EXPOSURE	$^1/_{400}$ second at f/4.5
WHITE BALANCE	Custom
LOCATION	Baton Rouge, LA
TIME OF DAY	Late afternoon
LIGHTING	Available light with reflector

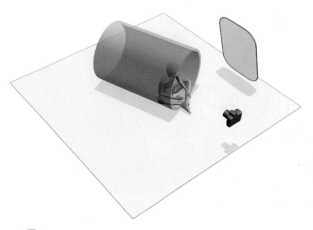

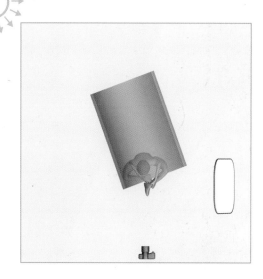

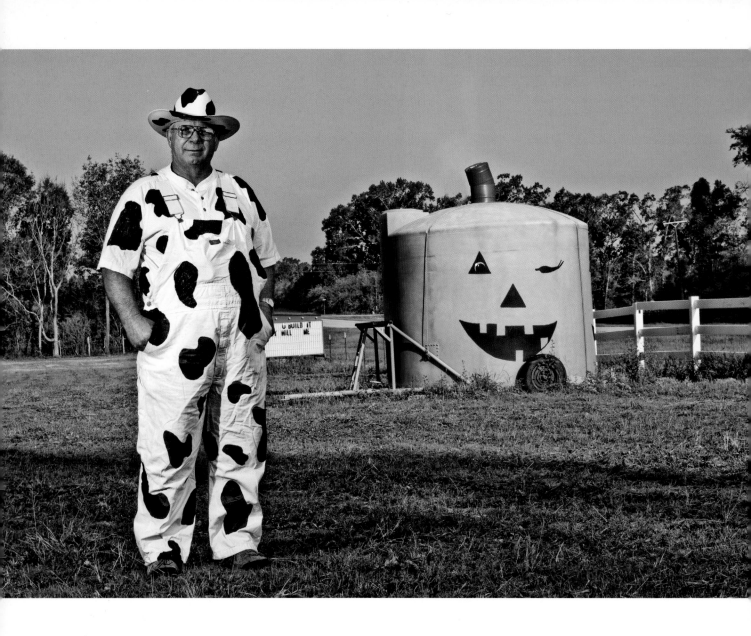

USE	Magazine article
CAMERA	Nikon D2Xs
FORMAT	Digital
LENS	35–70mm f/2.8
FOCAL LENGTH	48mm
ISO	100
EXPOSURE	$^1/_{100}$ second at f/9
WHITE BALANCE	Custom
LOCATION	Baton Rouge, LA
TIME OF DAY	8:47AM
LIGHTING	Electronic flash

5 | THE SCOOP

Photographing on location is always interesting, with ever-changing locations and subjects. For this shot, I was hired to photograph a man who owned a corn maze in rural Louisiana. When I arrived, the location was pretty sparse except for the giant pumpkin in the background. My subject was wearing cow coveralls, so I wasn't concerned about anything drawing attention away from him. I wanted to show my subject in context of his surroundings, and the pumpkin was important to his business because people could recognize it from the road.

TECH

This is a situation where I was happy to have been traveling with minimal gear. Because the site was very secluded, there would have been no opportunity to get power for strobes. I used a single electronic flash unit with a standard reflector as my main light. The subject was positioned out of the direct morning sun in shade that was created by the surrounding tree line at my back.

TIP

When working on location, it is important to manage the ambient light versus the strobes. In this situation, it was nice that the background was being lit by the rising sun. However, had the shade created by the tree line not existed, I would have had to *create* shade with scrims so that my subject was not facing into the sun. This is one reason why, when possible, location scouting is important: it allows you to ensure where the sun will be during the time of day you intend to shoot.

6 | THE SCOOP

Editorial assignments often allow me the ability to interpret a story. On many occasions, it is up to the photographer to conceptualize the image, find a location, scout, and finally shoot the image. While this all can be daunting—especially with ever-shrinking day rates—it actually affords some creative freedoms not associated with advertising work. So when it comes to editorial work, use it to strengthen your portfolio when at all possible.

TECH

This image is a great example of balancing flash with ambient light. A tree line created shade for my subject, but most of the background was in direct sunlight. I spot metered for the brightest points of the background light and matched my flash power to that exposure setting. A single electronic flash was used at camera right, positioned just above the tops of the corn stalks, so as to not cause shadows on my subject's face.

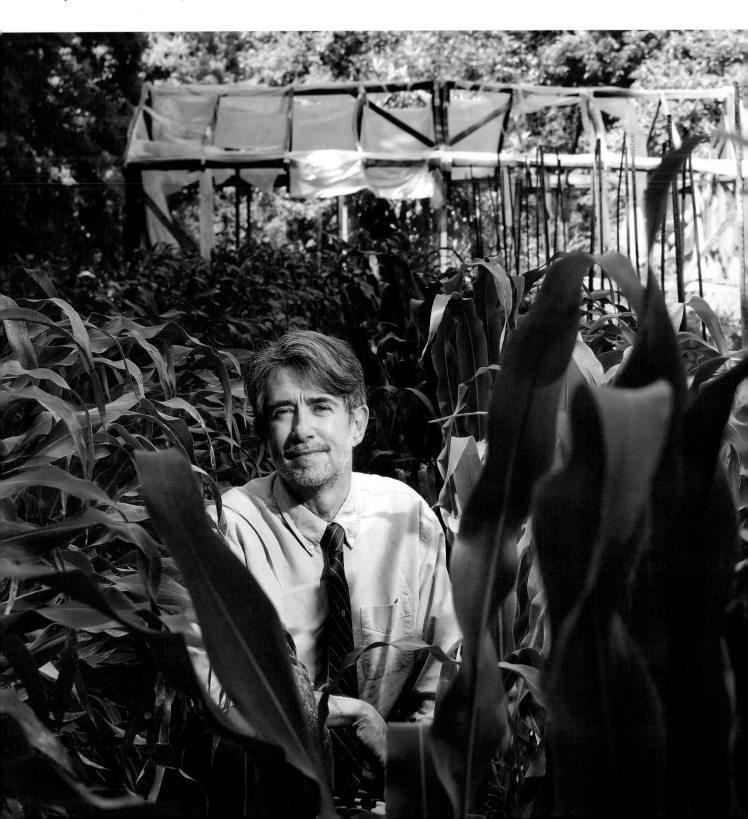

USE	Editorial
CAMERA	Nikon D2Xs
FORMAT	Digital
LENS	35–70mm f/2.8
FOCAL LENGTH	70mm
ISO	100
EXPOSURE	$^1/_{30}$ second at f/8
WHITE BALANCE	Custom
LOCATION	Baton Rouge, LA
LIGHTING	Electronic flash

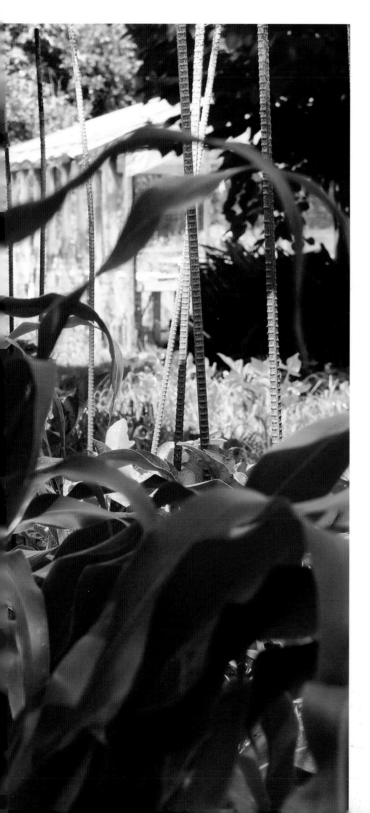

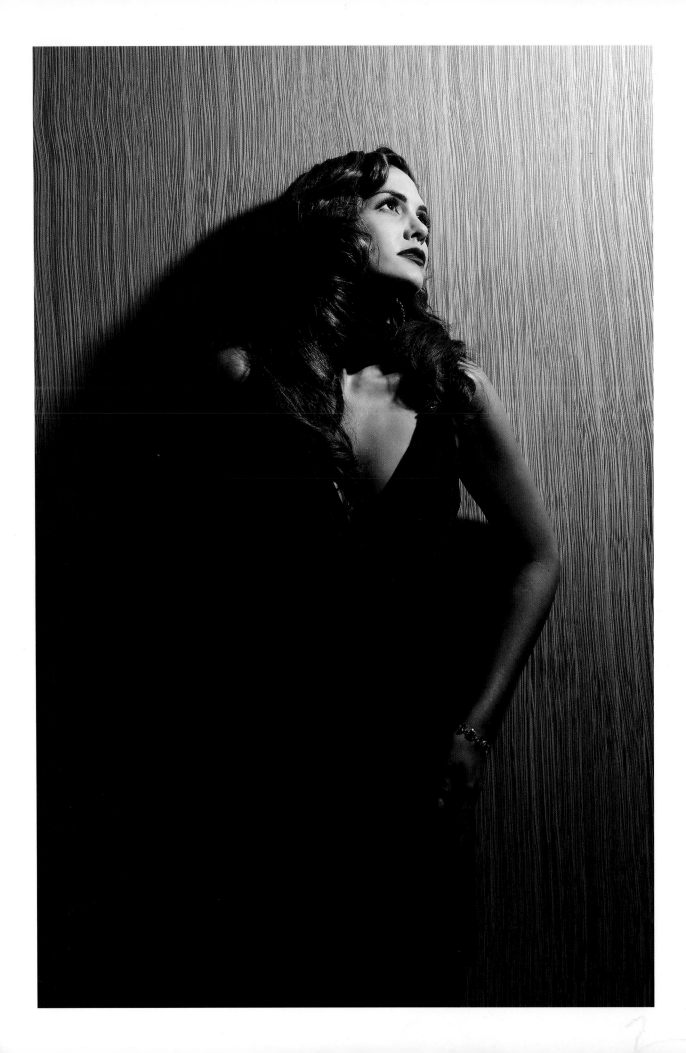

USE	Editorial
CAMERA	Nikon D2Xs
FORMAT	Digital
LENS	70–200mm f/2.8
FOCAL LENGTH	130mm
ISO	100
EXPOSURE	$^1/_{10}$ second at f/8
WHITE BALANCE	Custom
LOCATION	Baton Rouge, LA
LIGHTING	Electronic flash

7 | THE SCOOP

Sometimes when we previsualize images, the results outdo the image we had in our minds. This is one of those instances where the outcome surpassed my expectations. When I was photographing Miss Louisiana in a newly renovated hotel, I came across this wall. I loved the texture, but there wasn't much space.

TECH

A single Quantum flash was positioned on a stand overhead and as close to the wall as I could get it. I tried different variations, directing my model to focus on different portions of the frame; when working with heavy shadows, it is critical to find a position of the face that is most flattering. In this case, her upward gaze was the most appealing. By spot metering the point where the light from my flash hit the model's face—and by not using a fill source—I was able to get the bottom of the frame to fall into deep shadows.

8 | THE SCOOP

Not all images are as complicated as the final product may suggest. This image was captured in post-Katrina New Orleans as part of a calendar project to raise money for victims of the storm. We traveled all around the French Quarter creating this series of images, so limiting the amount of gear we were transporting was a must. In a city like the Big Easy, it is not uncommon to see models, photographers, and stylists marching through the streets from location to location.

TECH

This image was captured using a single electronic flash unit. The flash was fitted with a standard reflector, which created sharp, dramatic shadows and texture. Even small lights, when placed at a distance from the subject, can be more than enough for a full-body shot. In this photo, you can see that a lot of the ground space around the model is illuminated. The camera shutter was dragged to allow ambient light to reveal details in the surrounding buildings and alleyway. Heavy postproduction was used to finish the image.

USE	Promotional calendar
CAMERA	Nikon D2Xs
FORMAT	Digital
LENS	17–35mm f/2.8
FOCAL LENGTH	26mm
ISO	100
EXPOSURE	$^{1}/_{40}$ second at f/14
WHITE BALANCE	Custom
LOCATION	New Orleans, LA
TIME OF DAY	7:30PM
LIGHTING	Electronic flash

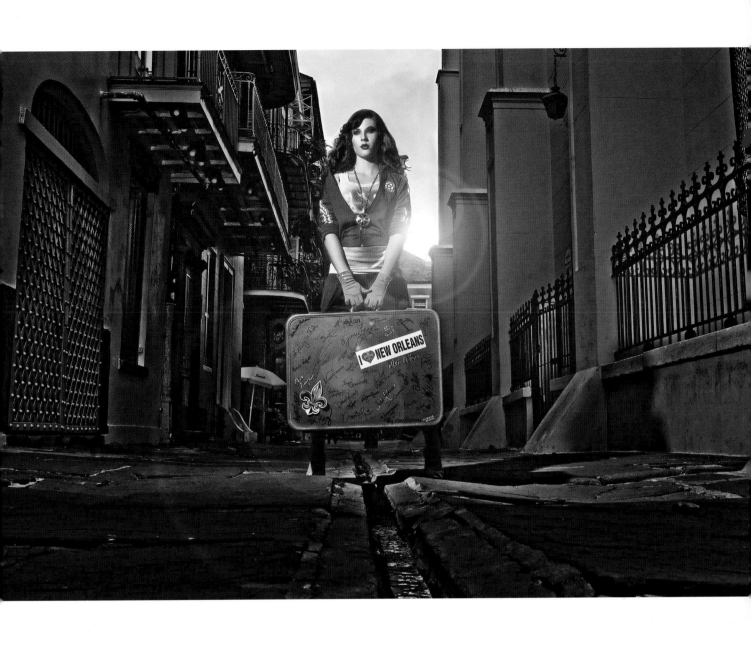

9 | THE SCOOP

The location that was chosen for this image was right at the top of a hill. The camera was actually rested on the ground, not on a tripod, down the hill from the subject—so, essentially, the camera perspective is below ground level from the subject's position. This gave the little girl a heroic stature. The image was to accompany a magazine article about the challenges that come along with raising special needs children. I have always loved the way the stalks of grass mimic mother and daughter in this image.

TECH

As is the case with most of my location lighting setups, I used one light and a reflector. The subject was positioned so that the morning sun slightly backlit her, then I spot metered the sky in the background and adjusted my flash to that setting to retain its detail and color.

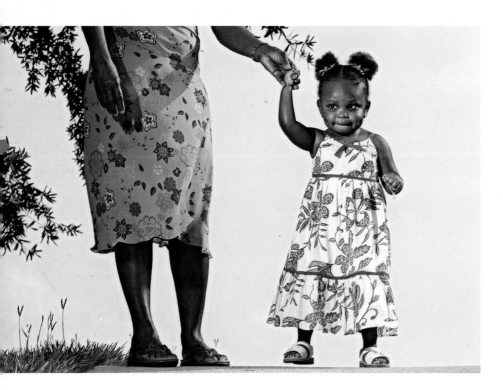

USE	Magazine article
CAMERA	Nikon D2Xs
FORMAT	Digital
LENS	70-200mm f/2.8
FOCAL LENGTH	95mm
ISO	100
EXPOSURE	$^1/_{100}$ second at f/11
WHITE BALANCE	Custom
LOCATION	Baton Rouge, LA
TIME OF DAY	Early morning
LIGHTING	Portable flash

USE	Editorial
CAMERA	Nikon D2Xs
FORMAT	Digital
LENS	35–70mm f/2.8
FOCAL LENGTH	40mm
ISO	100
EXPOSURE	$1/60$ second at f/4.5
WHITE BALANCE	Custom
LOCATION	Baton Rouge, LA
LIGHTING	Portable flash

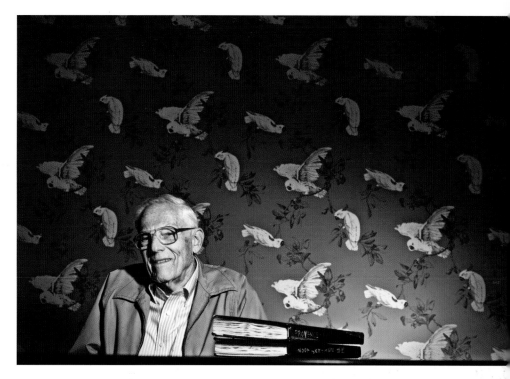

10 | THE SCOOP

Frequently, when on assignment, the details do not come together until the last second. When I was assigned to photograph an artist now living in a retirement home, the original intent was to photograph him in his apartment. However, because the room had no interesting angles and the light was bad, I made the decision to take him outside and do his portrait there. As he led me through the building, we walked through the dining area and I noticed this wallpaper covered in birds. I knew immediately that this was the perfect location for the image.

TECH

Two electronic flash units were used to create this image. One flash was used to light the background and one, fitted with a standard reflector, was used as the main. The background light was positioned on a chair behind the table, while the main light was placed on a light stand around six feet high. Both lights were triggered with slave units. A shallow depth of field was chosen to give some separation from the decorative wallpaper.

11| THE SCOOP

For this image of two businessmen, my client had requested that the men be photographed with the city in the background. There was only one vantage point where this could be done, and it would mean positioning the men in the direct sunlight. For this reason, I chose to photograph them in the early morning so that the rising sun would be at their backs.

In south Louisiana, it is extremely hot and humid—even in the early morning hours—and I knew that my subjects would be in business suits. When the gentlemen I was to photograph arrived at the location, I instructed them to park beside the spot I had set up, then remain in their air-conditioned vehicle until I was sure I was ready. I knew that I would only have a few moments before both men would begin sweating, so when I was ready I asked them to step in front of the camera and only photographed them for three or four minutes.

TECH

I used one strobe with a standard white umbrella as my main light. A silver reflector was set at camera left to generate some fill. I took an incident meter reading for the ambient light and set my exposure in accordance with the camera's maximum flash-sync speed. I then chose a lens that would give me the correct amount of coverage I was after.

TIP

This was one of those shoots where anything that could go wrong did go wrong—and nothing can drive home the importance of thorough location scouting more than one bad shoot. When I originally scouted the location for this image, I looked to see if there was power in the vicinity of my desired location. I noticed that there were electrical outlets nearby—but what I failed to do was check if these power receptacles were *active*. When I returned on the day of my shoot to begin setting up, I realized there was no power to the outlets. My subjects were on their way and I was scrambling to find power. A quick test with a voltage meter could have solved this problem.

USE	Magazine cover
CAMERA	Nikon D2Xs
FORMAT	Digital
LENS	35–70mm f/2.8
FOCAL LENGTH	48mm
ISO	100
EXPOSURE	$^1/_{100}$ second at f/11
WHITE BALANCE	Custom
LOCATION	Baton Rouge, LA
LIGHTING	Portable strobes

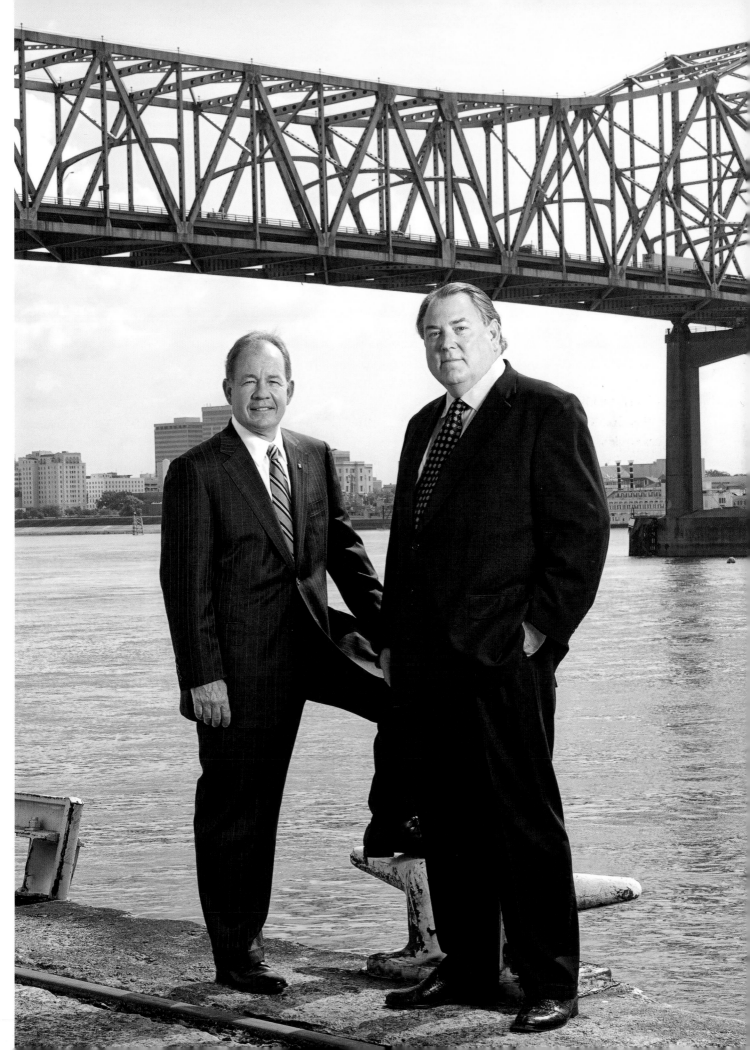

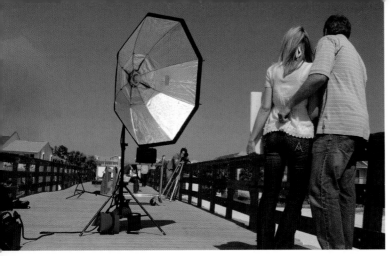

Photograph by Nabil Ashi.

12| THE SCOOP

This image was created for a bank to promote the bank's web site and express the feeling of "online banking." Although it was a hot summer day in Florida, finding a comfortable pose for my models and encouraging them to relax produced a calm and pleasing feeling in the image.

TECH

Overpowering the midday sun with flash is a great way to get bold, saturated lifestyle images. A light that is strong enough to overpower the bright sunlight is required for

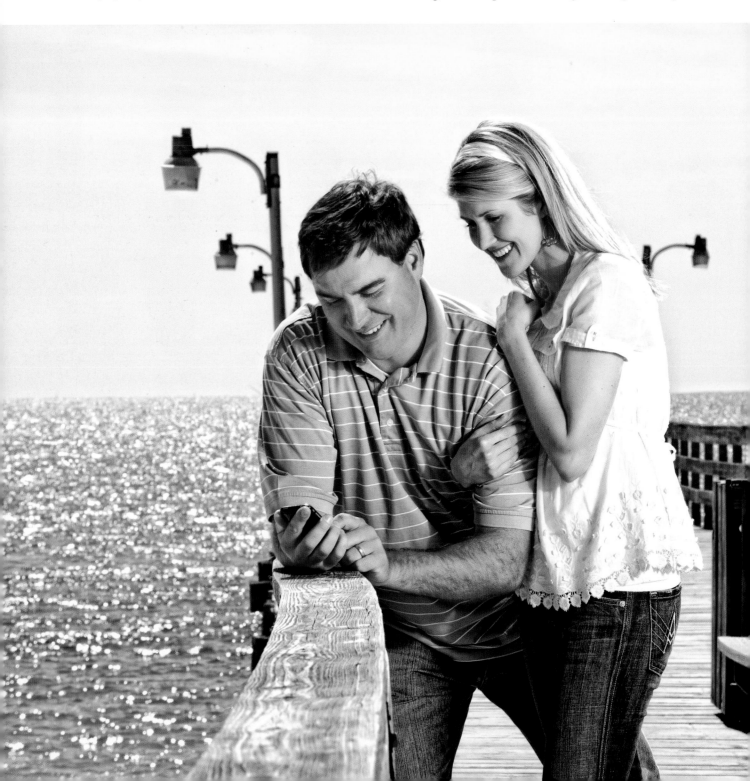

this technique, but the results are always pleasing. You can see from the bright light on the gentlemen's shoulders that, if not for the strobe, the couple would be entirely backlit and in shadow. Metering for the ambient light, then setting my flash (fitted with a five-foot Octabank) to match the reading resulted in a poppy, saturated image. (*Note:* In this situation, adjusting the camera settings for the shadowed side of the models would have resulted in an extremely overexposed background scene. Using a reflector would have torched the models with a continuous light source at the same intensity as the sun.)

TIP

Outdoors, the background scene will dictate how you will need to position your models and lights. If the background consists of standing objects, such as trees or buildings, backlighting your models with the sun will also result in a backlit and shadowed background. A better scenario would be to time your shoot for when the background is front lit, then knock the direct sun off of your models with large scrims. Strobes could still be used at this point to match the sunlight on your background.

USE	Advertising campaign
CAMERA	Nikon D3, tethered
FORMAT	35mm digital
LENS	70–200mm f/2.8
FOCAL LENGTH	130mm
ISO	200
EXPOSURE	$^1/_{125}$ second at f/18
WHITE BALANCE	Custom
LOCATION	Panama City, FL
TIME OF DAY	3:00PM
LIGHTING	Portable battery-powered strobes

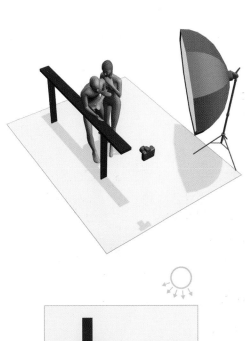

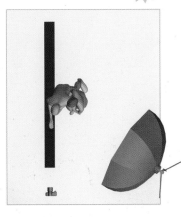

13 | THE SCOOP

Never underestimate what your subjects are willing to do for you to get the shot you want. Here, I was tasked with photographing an author who had won an award for a short story about the racial segregation of public swimming pools in the South. When I spoke with the art director, we decided to take her photo at a local public pool and I asked, "Do you think she would get in the pool?" The art director replied laughing, "It never hurts to ask." The author said she was up for the challenge—as long as she didn't have to wear a bathing suit.

TECH

The vantage point of the camera is from the lifeguard tower. The lighting was one strobe unit with a standard reflector fitted with a grid. It was a sunny morning, so I needed focused light at high power to overpower the sun. I metered for the water and the bottom of the pool, setting my exposure to make sure that the blue of the painted pool bottom would be very saturated. I was lucky with the wardrobe she chose for the shoot. Not only did the fabric move very nicely in the water, but the color was also a nice contrast with the blue pool.

USE	Magazine article
CAMERA	Nikon D2Xs
FORMAT	Digital
LENS	35–70mm f/2.8
FOCAL LENGTH	35mm
ISO	100
EXPOSURE	$1/100$ second at f/16
WHITE BALANCE	Custom
LOCATION	Baton Rouge, LA
TIME OF DAY	Early morning
LIGHTING	Portable strobe

14| THE SCOOP

This portrait of a family of Civil War re-enactors was photographed at their home in a suburban neighborhood. The intent of the photograph was to show the combination of old meets new. To do this, I positioned the family, dressed in their Civil War–era clothing, in front of their modern-day home.

TECH

The sun was not in the position I would have liked, so I used two large 4x6-foot scrims to block the direct sun from the entire group. I used a single monohead fitted with a standard umbrella (powered by an extension cord coming from the home) as the directional main light on the group. Strong negative space was left at the top of the frame for use in the design and layout of the magazine story.

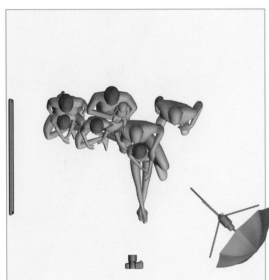

USE	Magazine article
FORMAT	Digital
LENS	35–70mm
FOCAL LENGTH	25mm
ISO	100
EXPOSURE	$^1\!/_{125}$ second at f/14
WHITE BALANCE	Custom
LOCATION	Baton Rouge, LA
LIGHTING	Portable strobes

15| THE SCOOP

The trucks in the background of this image were facing directly into the sun. This worked well to make the colors and details of the truck pop. However, shooting in this direction would have made my subjects have to face directly into the sun, as well. Fortunately I was able to use the shade from the building behind the camera to get my subjects out of the sun and light them with strobes.

TECH

One light with a softbox was used as the main at camera right. Another light was positioned at camera left, just out of frame, creating the side light on the men's faces. By balancing the artificial light with the ambient light, realistic yet bold results are possible.

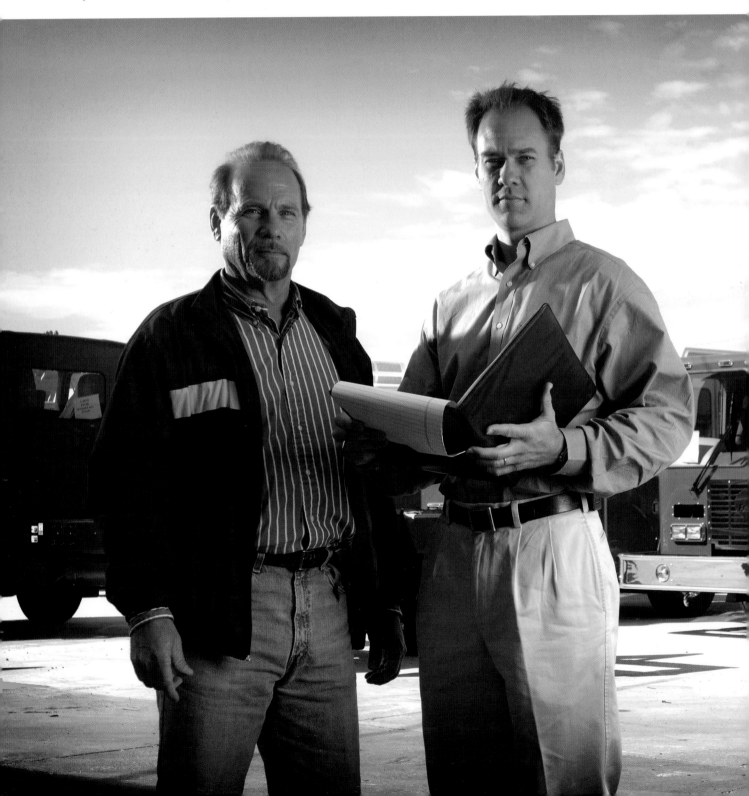

USE	Advertising campaign
CAMERA	Nikon D2Xs
FORMAT	35mm digital
LENS	35–70mm f/2.8
FOCAL LENGTH	35mm
ISO	100
EXPOSURE	$^1/_{125}$ second at f/10
WHITE BALANCE	Custom
LOCATION	Baton Rouge, LA
LIGHTING	Studio strobes

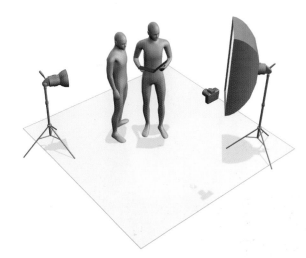

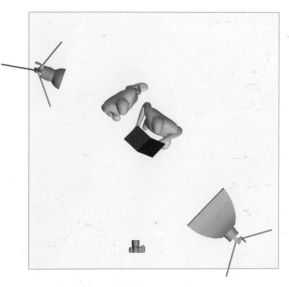

16 | THE SCOOP

To create a great image, sometimes we have to work with what we are given. I had specific thoughts in mind for this photograph that involved my subject being outdoors. When we arrived, however, we were informed that, because of health concerns, the subject was unable to get down the steps into the yard. We regrouped and set up the image on the patio to give us a feeling of the outdoors while keeping our subject comfortable. Choosing the proper camera angle and effectively using our lighting, we were able to create an image that maintained a lot of what we were originally after.

TECH

Knowing what your lights can do can get you through these situations with your previsualized image intact. Here, the camera's view gave me a glimpse of the outdoors while adding an element of texture that was a nice surprise. One

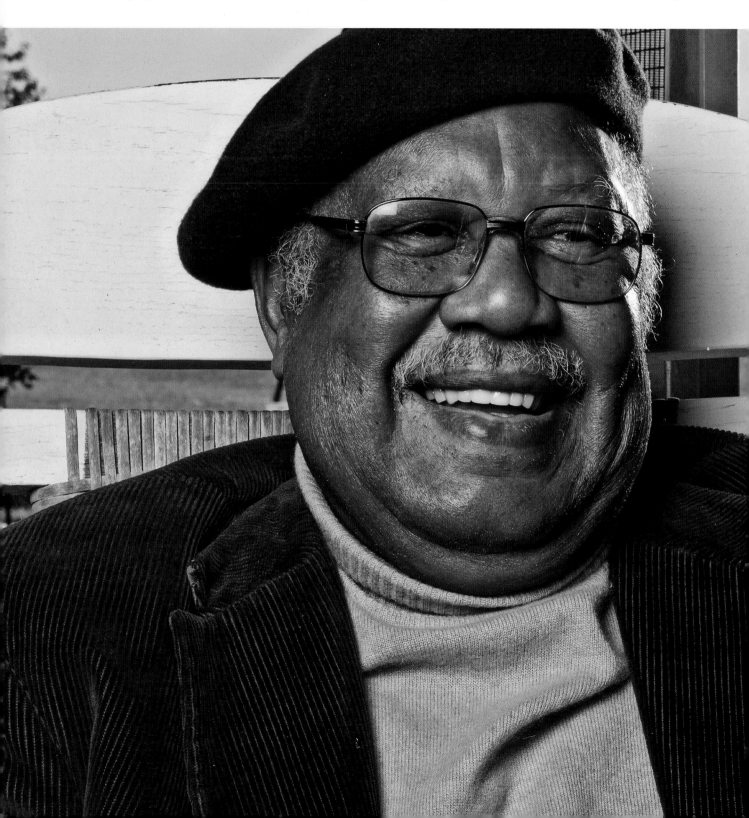

power pack was used with two heads. Meter readings were taken of the ambient light outdoors and the strobes were set to match this. The main head was equipped with a 4x6-foot softbox placed to camera left as the main light. Another light, with a cable extension, was run outside and aimed through the screen in the patio; this light had a grid on a standard reflector to create the edge light.

USE	Editorial
CAMERA	Nikon D2Xs
FORMAT	35mm digital
LENS	35–70mm f/2.8
FOCAL LENGTH	70mm
ISO	100
EXPOSURE	$^1/_{125}$ second at f/16
WHITE BALANCE	Custom
LOCATION	New Roads, LA
LIGHTING	Studio strobes

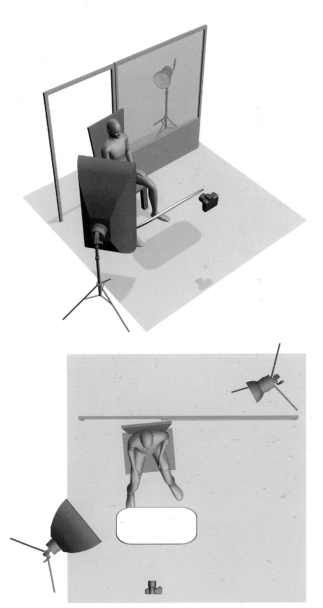

17 | THE SCOOP

When working to achieve results specific to an era, it is important to choose equipment that mimics what was available at the time. Here, the goal was to create a portrait that mimicked the styles of the 1950s and '60s. I used strobes to do these images instead of hot lights, but I used all hard light sources to achieve a look similar to what hot lights would have produced.

TECH

I positioned one light to camera right, at about shoulder height. It was far enough off camera to create some shading on my subject's face—but not so far as to make the shadow produced by his nose unflattering. When working with hard light sources, since the shadows are very defined, it is important to be careful with where the shadows are placed. Three more lights were used around the room to light the foreground and background.

USE	Private commission
CAMERA	Sinar 4x5 view camera
FORMAT	4x5 film (Kodak TMAX 100)
ISO	100
LOCATION	Baton Rouge, LA
LIGHTING	Studio strobes

USE	Advertising campaign
CAMERA	Nikon D3
	Tethered
FORMAT	35mm digital
LENS	70–200mm f/2.8
FOCAL LENGTH	160mm
ISO	200
EXPOSURE	$^1/_{100}$ second at f/22
WHITE BALANCE	Custom
LOCATION	Panama City, FL
TIME OF DAY	2:00PM
LIGHTING	Portable battery-powered strobes

18| THE SCOOP

Finding a great location at a perfect time of the day does not happen by accident. During this project, my team was working in tandem with a video crew. The print and video campaigns were schedule to coincide so that they could be produced at the same time. Many hours were spent picking locations that allowed the days of shooting to unfold seamlessly.

Once the video crew finished up their spots, my crew stepped in and set up the strobes. We wanted the still images to match the video production, but the two mediums require somewhat different approaches to lighting subjects. Whereas the video crew used only shiny boards (bounce reflectors) to illuminate their shots, I felt that the stills required a bit more pop.

TECH

A five-foot Octabank was used at camera right as the main light. A kicker was placed from behind, also at camera right and out of frame. The sun created the accent light on the model's right side. A small reflector was used behind the model to throw some light onto the bike in the background.

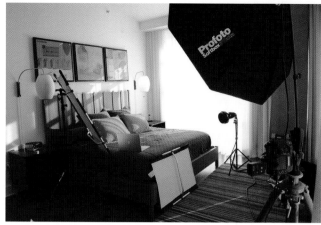

Photograph by Nabil Ashi.

19| THE SCOOP

In this image, the goal was to light the room as though it was illuminated by sunlight spilling in from outside. It was a third-floor room, so it would have been impossible to place lights outside. We solved the problem by selecting a time of day when light was coming through the window. Although the window light was not enough to adequately illuminate our subject, it was enough to create the illusion of natural light. Adding artificial light from the same direction as the streaking sun made the look believable.

TECH

Ambient spot meter readings were taken of the areas of the bed where the sun was hitting the pillows and headboard. I set my overall exposure to match those areas, so they did not blow out. One large umbrella was placed to the right of the camera and up around head height. Another light with a standard reflector was aimed at the corner of the ceiling and the wall, adding an overall fill to the room. Reflectors, placed to the left side and from below at the front of the bed, were used to add fill. The finished image appears light and airy—just what the client wanted.

USE	Advertising campaign
CAMERA	Nikon D3
	Tethered
FORMAT	35mm Digital
LENS	50mm f/1.8
FOCAL LENGTH	50mm
ISO	200
EXPOSURE	$1/100$ second at f/5.6
WHITE BALANCE	Custom
LOCATION	Panama City, FL
LIGHTING	Portable battery-powered strobes

20 | THE SCOOP

While on assignments, I sometimes have an idea for a photograph that is not necessarily going to be used but would be a great shot for my book or web site. In these instances, and when time allows, I like to try to get an extra image for myself after the main image has been captured.

In this case, I was hired to photograph a family of restaurant owners for a local magazine article. It was their twenty-fifth anniversary and the main image consisted of the entire family sitting around the dinner table with a cake. While we were making that image, I had the idea for this image. The owner of the restaurant had the fish and the kids were having fun while we were shooting, so the timing was just right.

TIP

While preparing for this image, I knew it would be difficult to get a great image of both of the children at the same moment. To solve this problem, I set my camera up on a tripod and set my focus to manual so that there would be no variation in focal length or camera position between images. I positioned the corner of the room directly in the middle of the image so that during postproduction I could simply find an image of the boy that I liked and image of the girl then split the image down the center using the line from the corner as a guide. The final result was an image with a lot of character and humor that would have been difficult to get in one single frame.

TECH

The lighting of this image was a bit tricky. My original image was of a large group sitting at a table and I wanted my perspective to be looking down the table at them. I knew I wouldn't be able to light from the end of the table closest to the camera because the main light would be more intense closer to the camera then fall off on the subjects who were further away, making the people at the other end of the table underexposed. To solve this, I rigged a crossbar that ran over the table and suspended a lantern in the center of the table. This ensured that everyone's faces would be lit evenly and there would be no falloff. For some edge light, and to help illuminate the room, I attached a light fitted with an umbrella on each of the vertical crossbar supports.

USE	Editorial
CAMERA	Nikon D2Xs
FORMAT	Digital
LENS	17–35mm f/2.8
FOCAL LENGTH	24mm
ISO	100
EXPOSURE	$^1/_{100}$ second at f/6.3
WHITE BALANCE	Custom
LOCATION	Baton Rouge, LA
LIGHTING	Portable strobes

USE	Personal project
CAMERA	Phase One P45+, Hasselblad H2
FORMAT	Medium format digital
LENS	55–110mm f/2.8
FOCAL LENGTH	70mm
ISO	100
EXPOSURE	$^1/_{250}$ second at f/7.1
WHITE BALANCE	Custom
LOCATION	Baton Rouge, LA
LIGHTING	Portable battery-powered strobes

21 | THE SCOOP

This image is another example of the teamwork between performing and visual artists. It was captured in an abandoned warehouse where I had wanted to create a series of images for a long time. I visualized the juxtaposition of the beautiful lines of the dancers contrasted with the gritty texture of the old building. It took some investigation and a lot of phone calls to get access to the location, but the site proved to be perfect for the shoot.

TECH

There was no electricity, so battery-powered lights were used to create these images. One 4x6-foot softbox was used as the main light. A second bare-bulb strobe was placed off set to camera right to add some light to the darkened building. In this image, a third light was placed on the first floor pointing up through the hole in the floor at the bottom left of the image.

TIP

I did my research on which battery powered lights had the shortest flash duration, but I overlooked the fact that (to save on battery charge) most battery-powered strobe packs have little to no modeling light. As the sun set, this was a big problem while trying to focus. Fortunately, a friend had come to the set to shoot some video and happened to bring a generator with a hot light, which created just enough ambient light to focus.

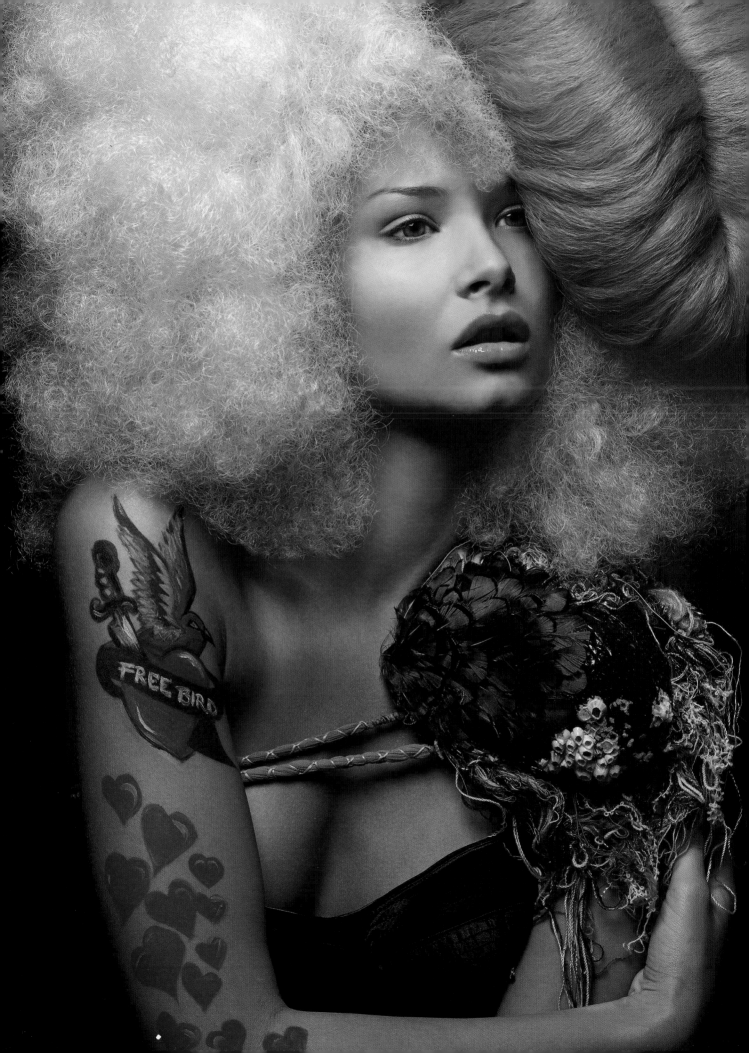

22| THE SCOOP

When working with stylists to capture their own artistic creations, beautiful lighting coupled with a great expression and emotion makes the image. Often, complicated lighting is needed to show all of the information that needs to be shown. Sometimes, on the other hand, it is as simple as one light.

TECH

Lighting does not get any easier than this. One beauty dish was used on a mini-boom overhead. No fill or background light was used. When I started lighting this image, I began with three lights—but because the styling was so dramatic, I found the extra lights to be overkill. I backed off to the one main light and found the simple lighting had more impact than the more complex set.

TIP

When metering and positioning my lights for a classic butterfly lighting scenario, I find it is best to use the tip of the model's nose as reference. I take many meter readings around the model's face, trying to get the tip of the nose to have the highest reading. I also position the light to stay flat with the nose. This spreads the "butterfly" drop shadow evenly across the underside of the model's nose. In this image, I went for slightly more of a broad lighting effect, introducing just a touch of shadow on the far side of the model's face.

USE	Hairdresser's contest entry
CAMERA	Phase One P45+, Hasselblad H2
FORMAT	Medium format digital
ISO	100
WHITE BALANCE	Custom
LOCATION	Miami, FL
LIGHTING	Studio strobes

USE	Contest entry
CAMERA	Phase One P45+, Phase One 645
FORMAT	Medium format digital
LENS	55–110mm f/2.8
FOCAL LENGTH	70mm
ISO	400
EXPOSURE	$^{1}/_{250}$ second at f/7.1
WHITE BALANCE	Custom
LOCATION	Orlando, FL
LIGHTING	Studio strobes

23| THE SCOOP

When photographing on location, it can be challenging to find locations that are interesting and work with what you are trying to accomplish. For this image, I decided to place the model inside a conference room and shoot back through the glass at her. It wasn't until the last moment that I had the idea to spray the glass with water.

TECH

This is another example of how powerful one light can be. A single beauty dish on a mini boom stand was used overhead to create this image. The model was placed behind a window that was misted with water. Black muslin was placed as the background. Special care was taken to ensure the reflections of the photographer and the styling team were not visible in the window.

TIP

When placing the light in a position that gets the shine of the hair just right, you will frequently lose the catchlights in the eyes, making them appear lifeless. In this image, adding a reflector below the model not only opened up the shadow details, it created catchlights in her eyes.

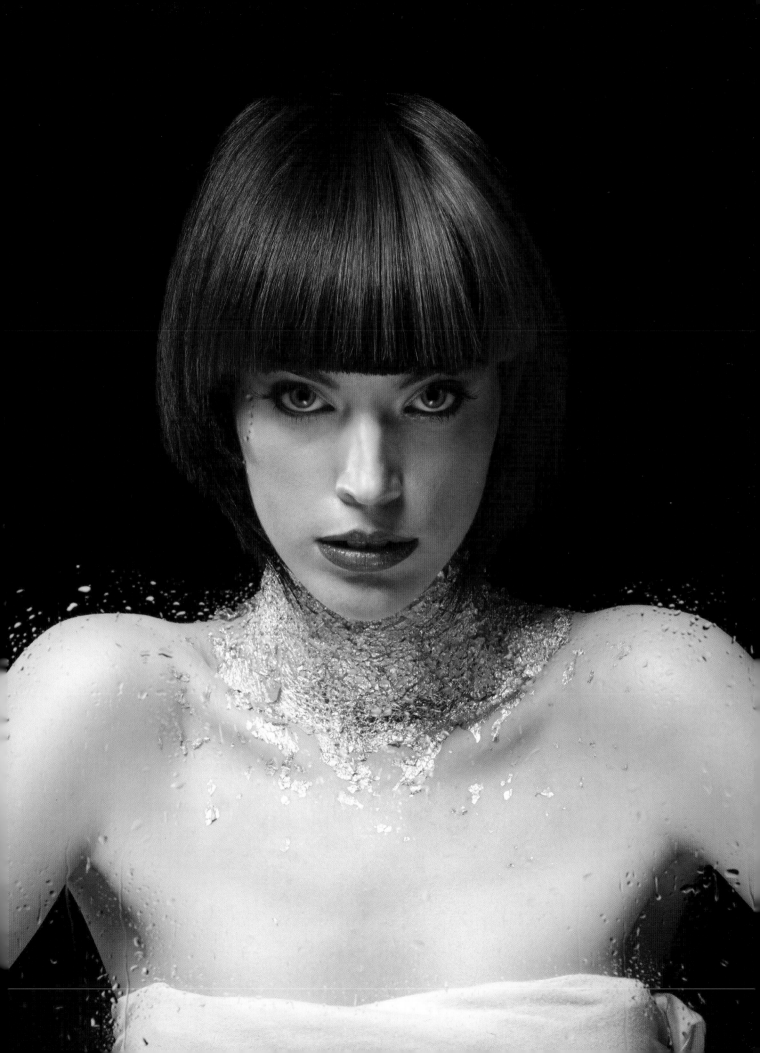

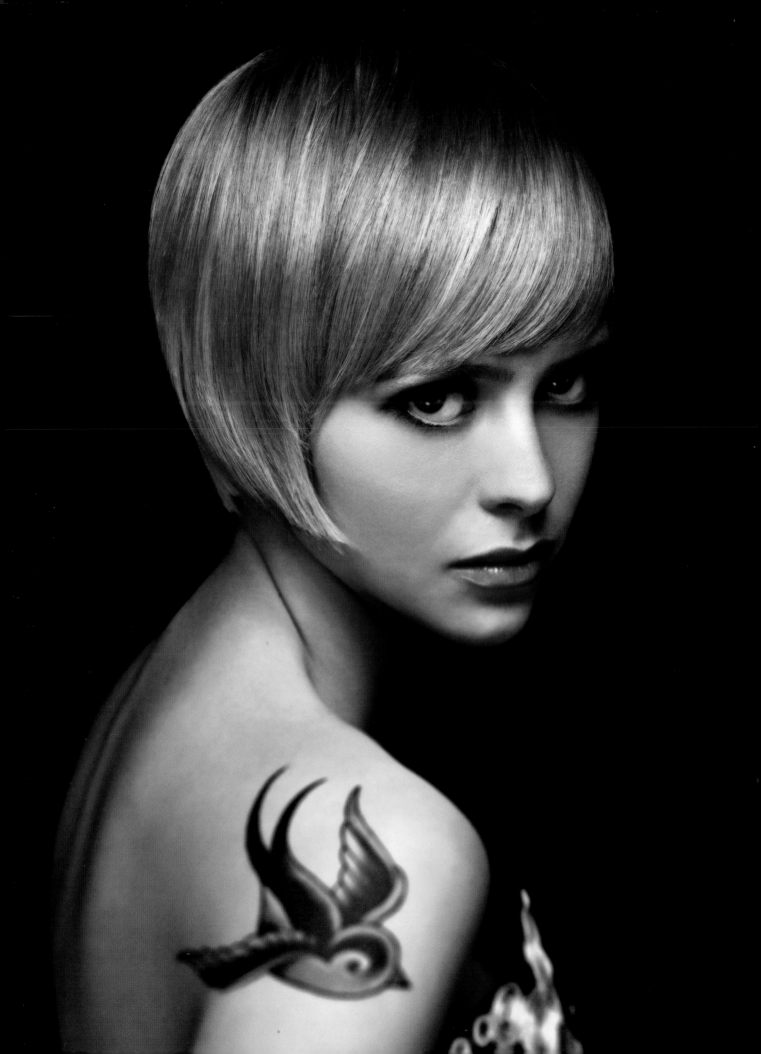

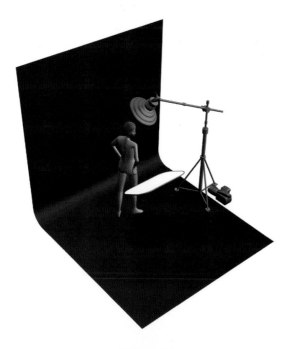

USE	Competition entry/advertising
CAMERA	Phase One P45+, Phase One 645 Tethered
FORMAT	Medium format digital
LENS	110mm f/2.8
FOCAL LENGTH	70mm
ISO	50
EXPOSURE	$1/160$ second at f/18
WHITE BALANCE	Custom
LOCATION	Fort Lauderdale, FL
LIGHTING	Studio strobes

24| THE SCOOP

Light hair and fair skin on a black background can be an amazing combination. That is the case here, where the model's eyes grab your attention. The negative space in this image is just as important as the subject. The pose was selected to echo the shape of the hair and the tattoo. Sometimes, it is important to get the model on set and let them move until the most flattering angle is found. Once that position is set, the light can be adjusted from that point. That was the case with this image. When photographing a model for the beauty industry, it is always a careful balancing act between aesthetics for the model and for the product that is being sold.

TECH

This image was created on a one-light set. A single beauty dish was used overhead. A silver reflector was used from below to fill in the eyes.

USE	Charity calendar
CAMERA	Nikon D2Xs
FORMAT	Digital
LENS	35–70mm f/2.8
FOCAL LENGTH	70mm
ISO	100
EXPOSURE	$^1/_{125}$ second at f/13
WHITE BALANCE	Custom
LOCATION	Baton Rouge, LA
LIGHTING	Studio strobes

25 | THE SCOOP

This image was produced for the October spread of a calendar to raise money for a local charity. It is another example of the power of a one-light setup.

TECH

I wanted the ears of his costume to make a shadow on the background behind him, reminiscent of the comic books and cartoons I remember as a child. To do this, I chose to use one focusable Fresnel spotlight; it gave me enough coverage to light the entire scene but was focused enough to give me the well-defined shadow on the background.

I focused the Fresnel to a point where the shadow was blurred enough for the shape to read on the background but soft enough to not take your attention away from the subject.

26 | TECH

Simple, hard lighting is sometimes all that is needed when doing beauty work. Here, a single focusable Fresnel was used as the main light. A four-foot strip light was placed on a boom over the model's head out of frame. The strip light was flush with the wall and added some needed fill to the crown of the model's head.

USE	Advertising campaign
CAMERA	Phase One P30+
	Phase One 645
	Tethered
FORMAT	Medium format digital
LENS	150mm f/2.8
FOCAL LENGTH	120mm
ISO	100
EXPOSURE	$^1/_{125}$ second at f/18
WHITE BALANCE	Custom
LOCATION	St. Petersburg, FL
TIME OF DAY	N/A
LIGHTING	Studio strobes

USE	Commissioned portrait
CAMERA	Nikon D2Xs
FORMAT	35mm digital
LENS	17–35mm f/2.8
FOCAL LENGTH	24mm
ISO	100
EXPOSURE	$^1/_{125}$ second at f/18
WHITE BALANCE	Custom
LOCATION	Baton Rouge, LA
LIGHTING	Studio strobes

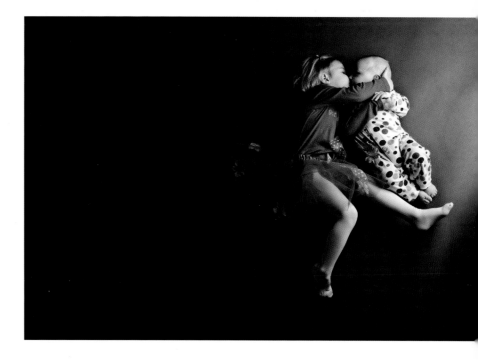

27 | THE SCOOP

When photographing children of differing age groups, it can be hard to find ways of posing them that appear natural and comfortable. In this case, working with a toddler and a baby, I chose to simply let them lay on the floor of the studio.

TECH

One 2x4-foot softbox fitted with an egg crate grid was used to create this unique perspective of a sister and her baby brother. The grid focused the light into a confined space. The light being low to the ground and angled slightly upward helped it to fall off, letting the left side of the frame fall to darkness. I stood on a step stool and used a wide-angle lens to get above the two.

USE	Contest entry
CAMERA	Phase One P45+, Phase one 645
FORMAT	Medium format digital
LENS	150mm f/2.8
FOCAL LENGTH	120mm
ISO	100
EXPOSURE	$^1/_{100}$ second at f/4
WHITE BALANCE	Custom
LOCATION	Orlando, FL
LIGHTING	Studio strobes

28| THE SCOOP

Sometimes things outside of our control can foil the best drawn-up plans. Originally, I had wanted to do this image outside. Given that we were shooting in south Florida in the summer, I knew the only way to do this comfortably was early in the morning. The shoot was scheduled to start at 9:00AM, however unforeseen delays with the styling team pushed the shoot well into the afternoon. We tried to do the shot outside, but the heat was unbearable, so I decided on another option.

TECH

To get the look of an outdoor shot but remain in the comfort of air conditioning (for our model's sake), I placed the model in a doorway. I took an ambient meter reading for the trees in the background and set my lights to match that reading. I used a single flash head fitted with a Fresnel spot to mimic the sun. The resulting image appears to have been photographed in the direct sun but was actually a combination of ambient and artificial light. A reflector was placed outside for the bit of edge light you can see on the model's neck and shoulder.

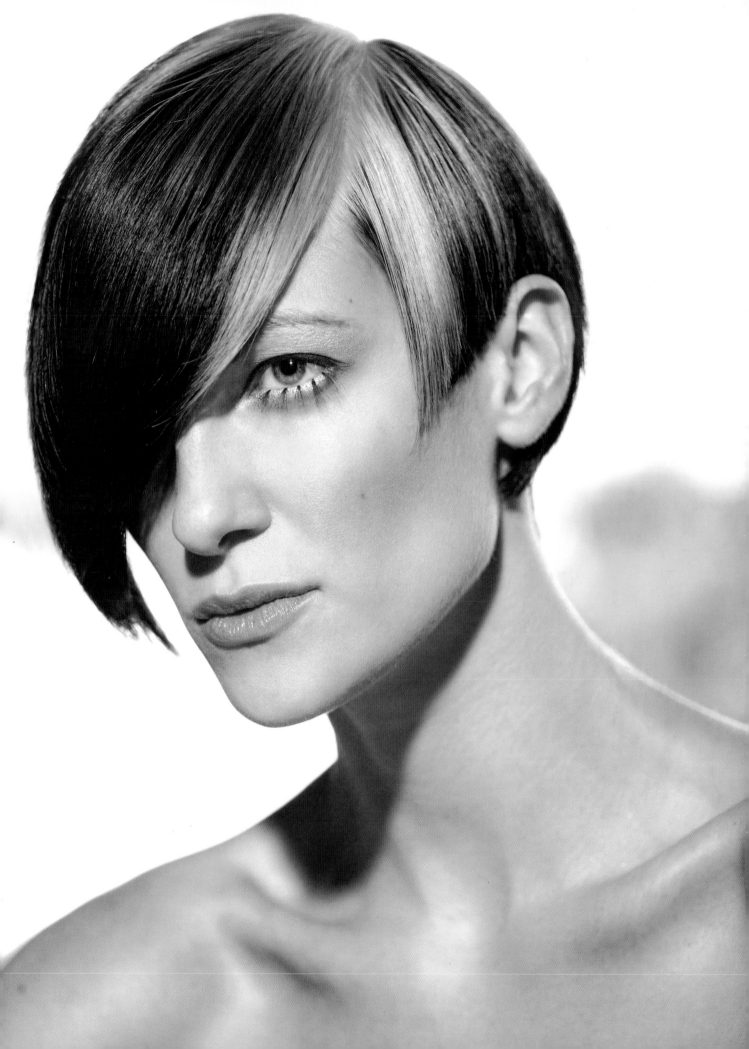

29 | THE SCOOP

When photographing actors for their promotional materials, it is a good idea to keep your lighting as simple as possible. Casting agents who are searching for acting talent like to see what a potential selection looks like without distractions or excessive embellishment. By keeping the lighting simple, you make the image a quick read of an actor's facial features and overall appearance.

TECH

This is another example of how simple lighting can be when the right decisions are made for the right subject. Here, one medium softbox was used overhead. One reflector was used from below to add some upward fill. A digital "cross-processing" effect was used by selecting the tungsten white balance setting while using studio strobes; this created an overall cool blue tone to the image. Texture and grain were also applied for added effect.

USE	Actor's portfolio
CAMERA	Nikon D2Xs
FORMAT	Digital
LENS	70–200mm f/2.8
FOCAL LENGTH	86mm
ISO	100
EXPOSURE	$^1/_{125}$ second at f/13
WHITE BALANCE	Tungsten
LOCATION	Baton Rouge, LA
LIGHTING	Studio strobes

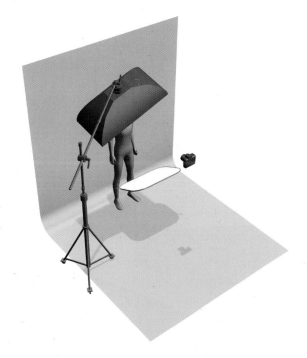

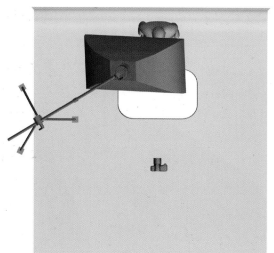

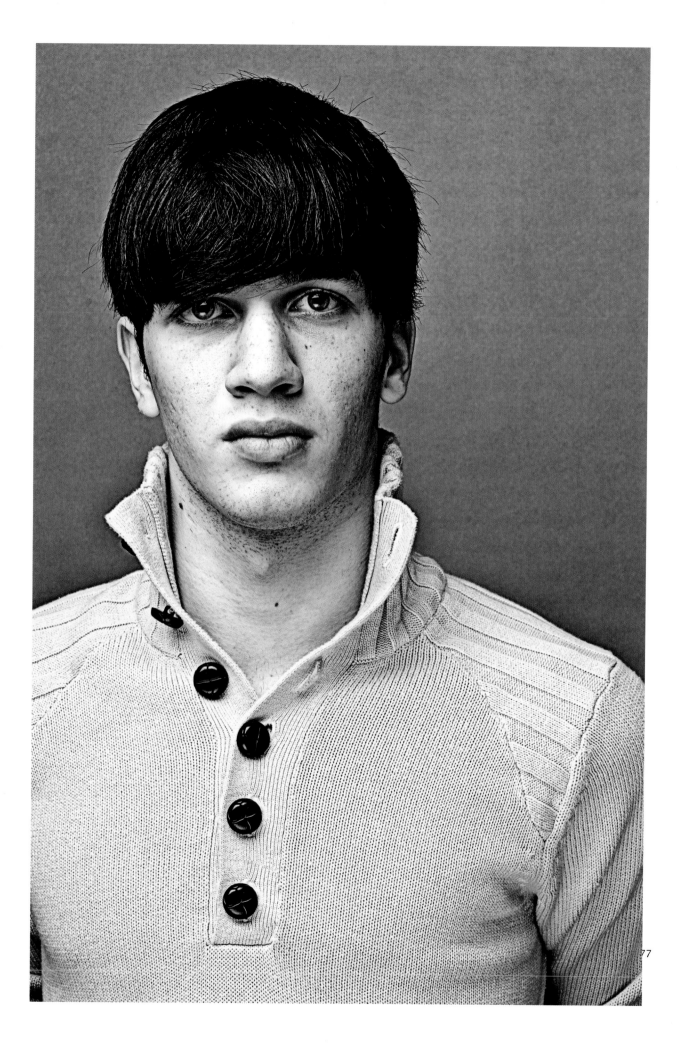

30| THE SCOOP

Sometimes art happens when we least expect it. Keep your camera ready—even when no one else is prepared to shoot. This shot came while the stylists were trying different looks with the model's hair. The team happened to brush the model's hair over her face and as soon as their hands were out of the frame I snapped a shot. It was not the image that was ultimately used in their contest entry, but I loved the overall feel of this shot—especially in black & white.

TECH

One beauty dish fitted with a grid was used to create this image, with no fill reflector. A snooted light was used, but it was originally falling on the very bottom of her hair. Because this image was a bit candid, the lights had not been reset for the model's head movement; however, it fell in a lucky spot and adds to the drama.

TIP

Images like this teach you always to be ready. Sometimes, things will catch your eye in a brief moment that would be hard to recreate in a controlled environment. Some of the best images can never be recreated.

USE	Contest entry/advertising
CAMERA	Phase One P30+, Hasselblad H2
FORMAT	Medium format digital
LENS	150mm f/2.8
FOCAL LENGTH	24mm
ISO	100
EXPOSURE	$1/100$ second at f/25.4
WHITE BALANCE	Custom
LOCATION	Houston, TX
LIGHTING	Studio strobes

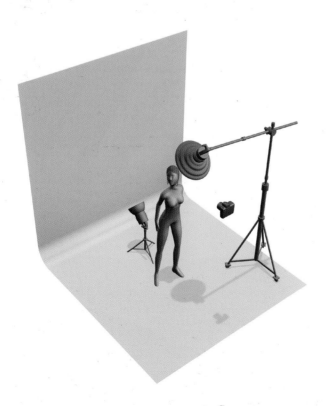

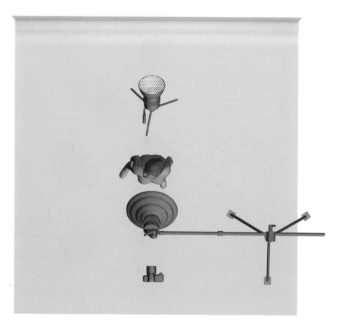

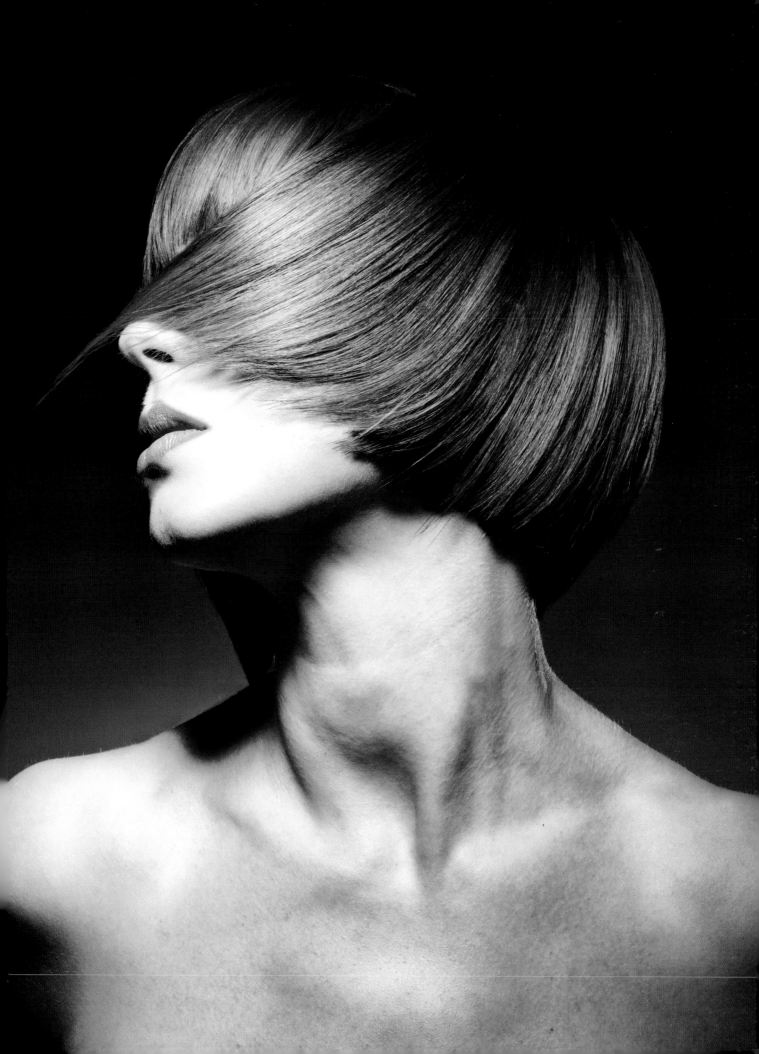

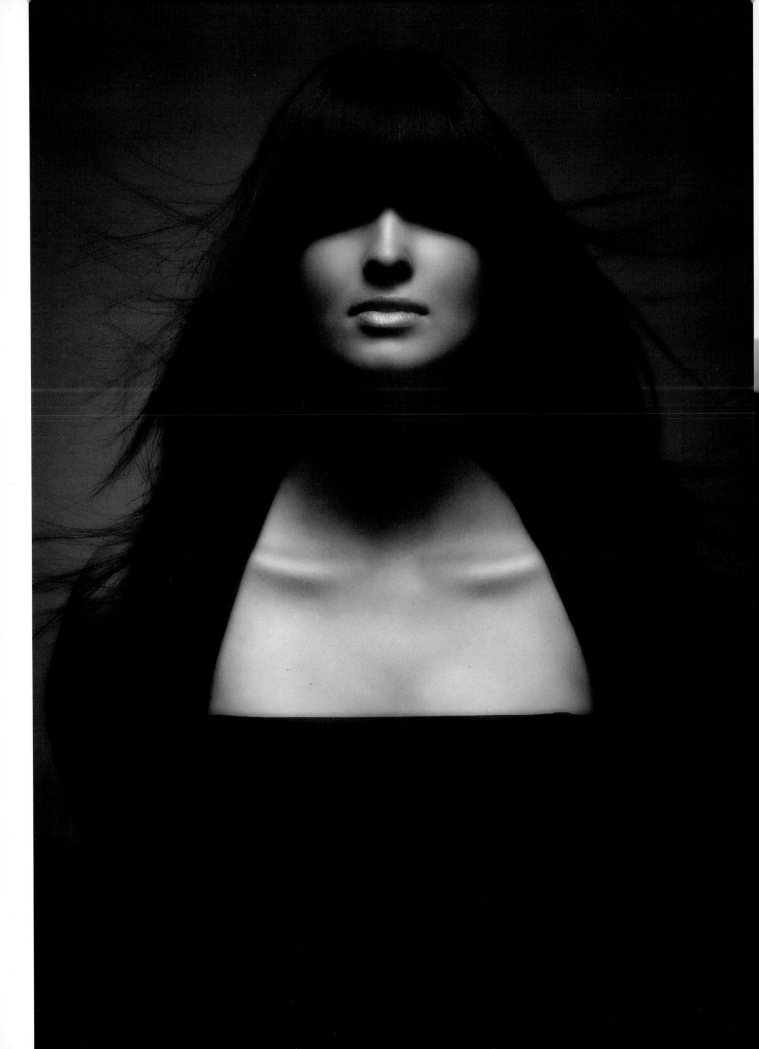

31 | THE SCOOP AND TECH

This image has come to be one of my most recognizable images—as well as one that illustrates my style and lighting approach. The simplicity of the lighting, coupled with the air of mystery, is something that I strive for in all of my images.

TIP

Using a single overhead main light, one background light, and no reflector, I was able to maintain the deep shadows and allow the eyes to fall into deep shadows. The main light was placed overhead to light the hair and shadow the eyes, while still illuminating the face. Two hair dryers, fitted with makeshift snoots made out of paper, were used to get motion on the longer portions of the model's hair while leaving her bangs still.

USE	Advertising
CAMERA	Nikon D2Xs
FORMAT	Digital
LENS	35–70mm f/2.8
FOCAL LENGTH	70mm
ISO	100
EXPOSURE	$^1/_{125}$ second at f/8
WHITE BALANCE	Custom
LOCATION	Baton Rouge, LA
LIGHTING	Studio strobes

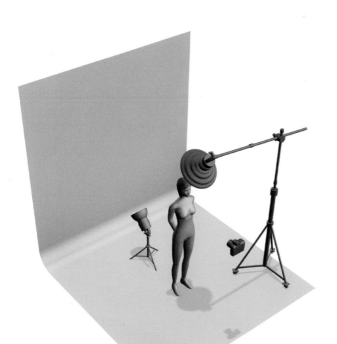

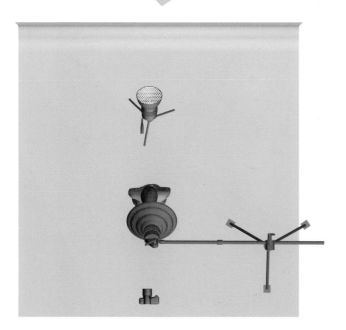

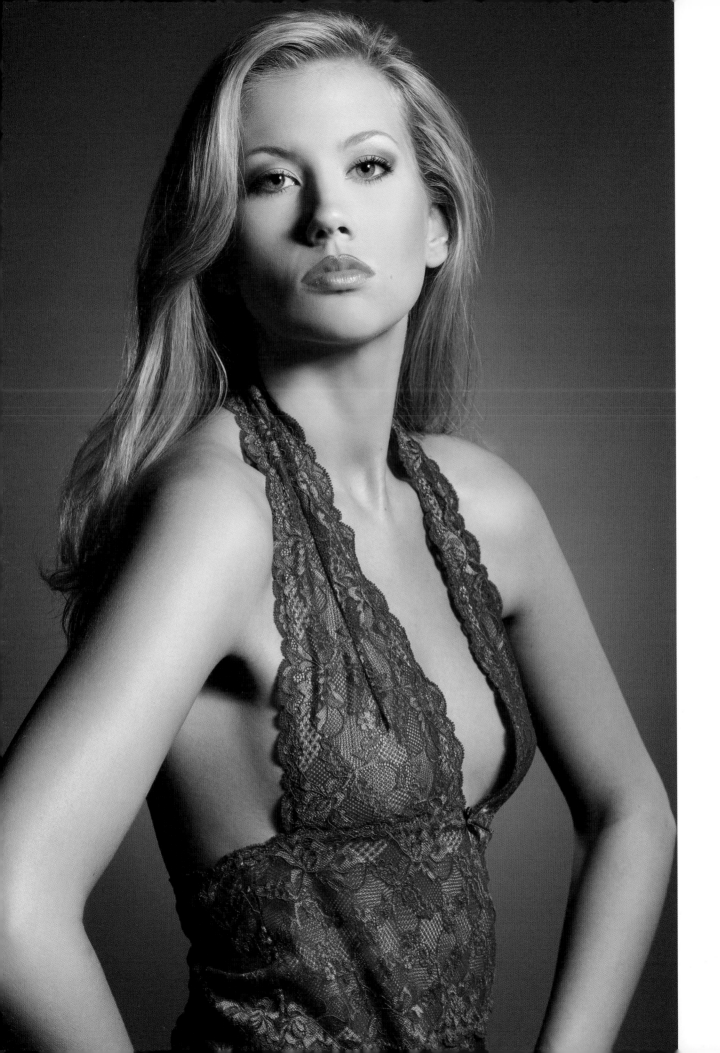

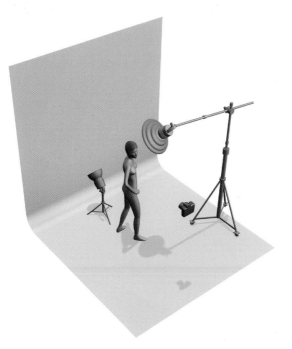

32| THE SCOOP

Just as when working with actors' headshots, when creating headshots for a model's portfolio it is a good idea to keep things as simple as possible. This allows your subject to show casting agents or art directors what they have to offer without complicated lighting setups distracting from their look.

TECH

This image was created with a beauty dish angled down toward the model's face from slightly above head height. A second light was placed on a stand behind the model to light the background, giving separation and a natural vignette.

USE	Model's portfolio
CAMERA	Nikon D2Xs
FORMAT	35mm digital
LENS	70–200mm f/2.8
FOCAL LENGTH	70mm
ISO	100
EXPOSURE	$^1/_{125}$ second at f/8
WHITE BALANCE	Custom
LOCATION	Baton Rouge, LA
LIGHTING	Studio strobes

33| THE SCOOP

I was always taught that, as a general rule, when photographing African American models it is safe to go with a large light source. The reasoning is that the larger light source will be better able to open up the shadows on darker skin and properly light for the generally darker eye color.

Unfortunately, large light sources also mean soft light qualities. Given that this was a photograph for a hair-care brochure, I wanted to make sure that I maintained crisp details in the skin and hair—and at the same time, achieved bright, even illumination on the model.

TECH

I chose to light this series with a giant eight-foot umbrella (Profoto's "Giant Reflector"). This large light is designed to offer very broad coverage while still maintaining sharp, specular highlights. The umbrella acted as the main light and one additional light was used to create the gradation on the background. No fill reflectors were needed.

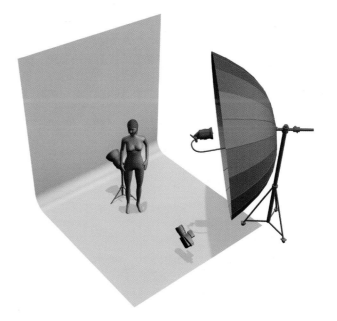

USE	Advertising
CAMERA	Hasselblad H2 with Phase One P21
FORMAT	Digital
LENS	Hasselblad 50–110mm f/3.5–4.5
FOCAL LENGTH	90mm
ISO	100
EXPOSURE	$^1/_{125}$ second at f/22
WHITE BALANCE	Custom
LOCATION	Hammond, LA
LIGHTING	Studio strobes

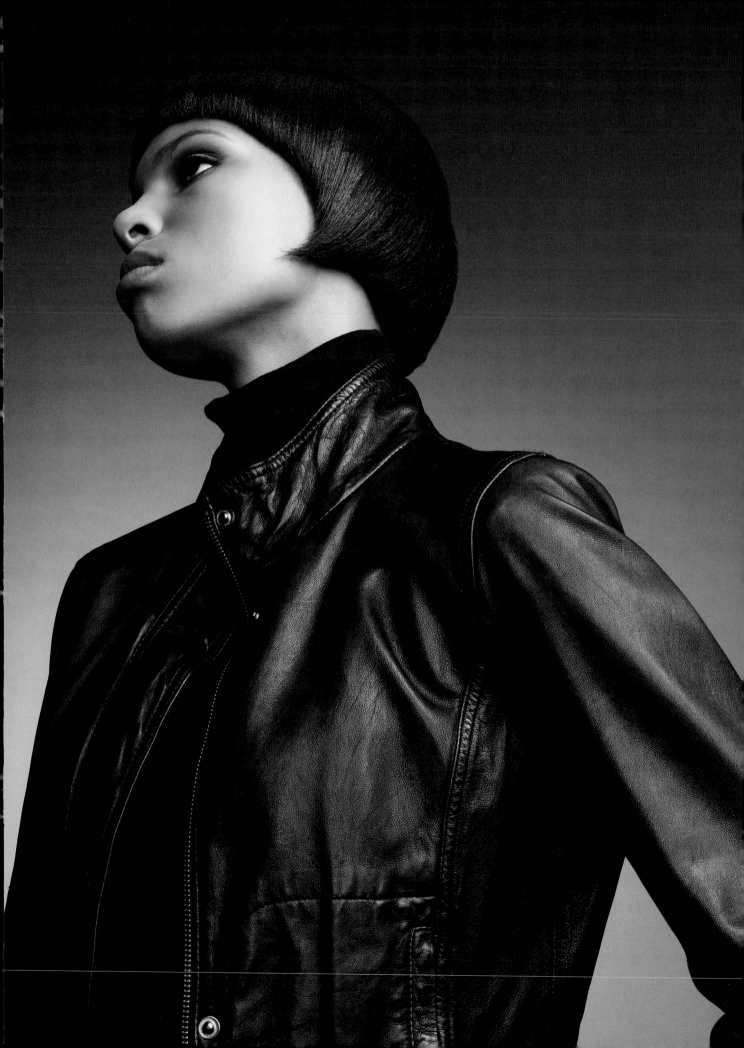

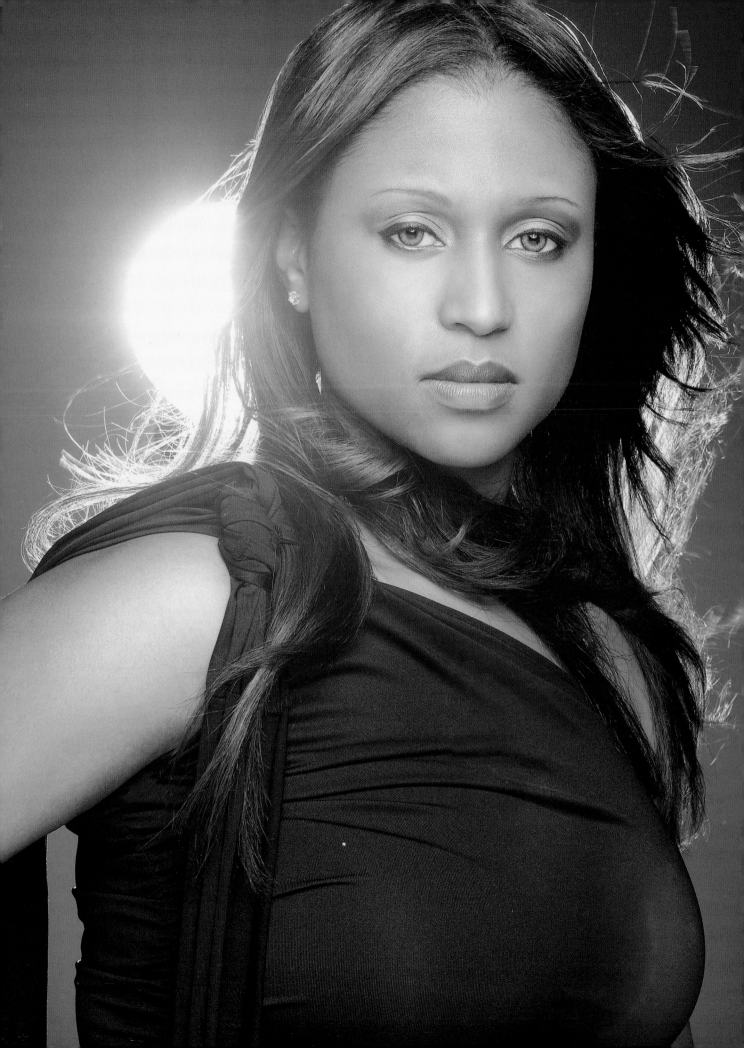

34| THE SCOOP

Lighting concepts can grow easily while testing lights. I will sometimes put a light behind a model to get a glowing halo effect. In this case, I noticed that sometimes the model would move or I would change angles and the light would peak out from behind her head. Sometimes it worked and sometimes it didn't—but I found that by controlling the power of the strobe (as well as the amount of the light that was exposed), it could add a great detail without becoming overpowering.

TECH

A butterfly lighting effect was created in this image using a Mola beauty dish as the main light with a reflector from below at waist height, just out of frame. Except for the addition of the backlight pointed directly at the camera, no other lights were used.

TIP

An important element in this image is the movement of the model's hair. This effect has been used for years in the portrait, glamour, and fashion worlds to add a bit of motion to an otherwise still image. I find that a touch of wind, combined with a confident and strong pose, can lead to a bold and intriguing image.

USE	Private commission
CAMERA	Nikon D2Xs
FORMAT	35mm Digital
LENS	35–70mm f/2.8
FOCAL LENGTH	70mm
ISO	100
EXPOSURE	$^{1}/_{125}$ second at f/11
WHITE BALANCE	Custom
LOCATION	Baton Rouge, LA
LIGHTING	Studio strobes

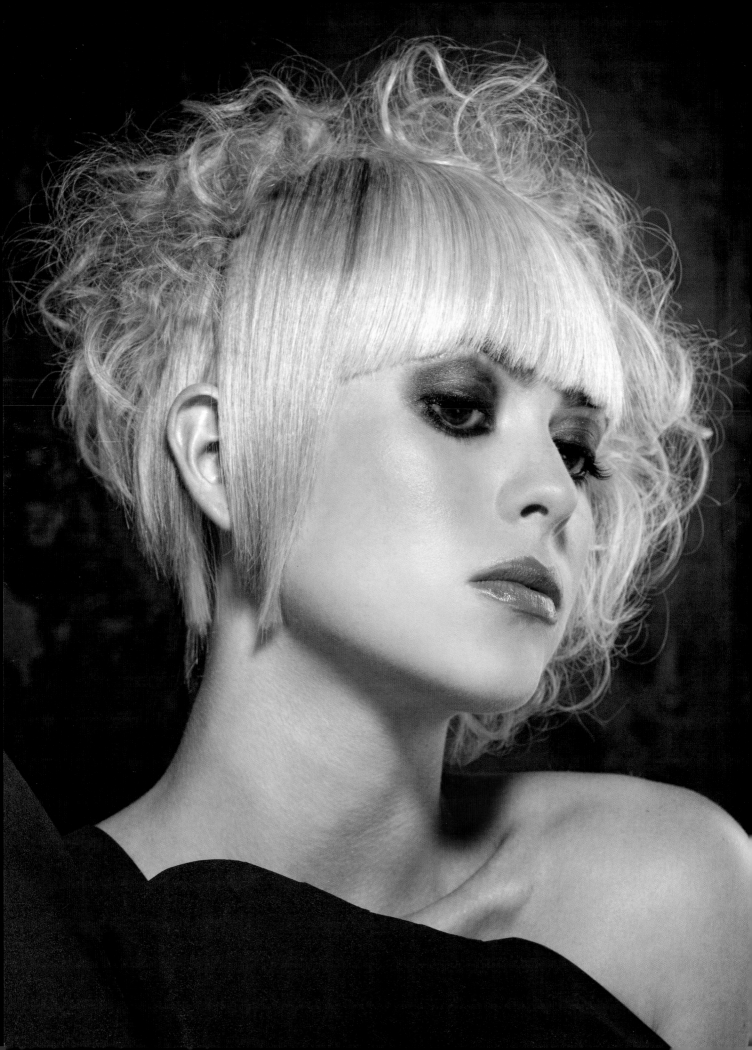

35 | THE SCOOP

Working in different locations can be tricky at times, but it can also lead to interesting backgrounds and locations. For this image, three steel benches were placed on end behind the model to create the textured background. They were set far enough behind the model to fall out of focus but close enough to cover the frame.

TECH

One overhead beauty dish was used as the main light and a silver reflector was used from below to add a bit of fill, lessening the shadow under the chin. A softbox strip light was used at camera right for fill, as well as to add a little illumination to the background. It was important that the faint blue coloring of the hair read in the image. This can be difficult with lighter hair, but it is manageable with careful metering.

USE	Contest entry/advertising
CAMERA	Phase One P45+, Phase One 645
FORMAT	Medium format digital
LENS	55–110mm f/2.8
FOCAL LENGTH	70mm
ISO	50
EXPOSURE	$\frac{1}{60}$ second at f/16
WHITE BALANCE	Custom
LOCATION	Orlando, FL
LIGHTING	Studio strobes

36 | THE SCOOP

The art director for this hair shoot was looking for a highly graphic image. My team was able to facilitate this by using some techniques that added a bold touch but maintained the integrity of the hair and makeup. I generally start with one main light and add lights specifically where they are needed, rather than setting up the entire set blind.

TECH

The shoot began with one gridded beauty dish placed overhead, illuminating the hair and face. The model moved around into some different positions until we found a pose that was both flattering for her face shape and the hair style. Once the position was locked in, lights were added to bring up certain areas. One fill light was added from behind the model's right shoulder, just out of frame. Barn doors were used to eliminate spill from this onto the model's shoulder. Another light, also for fill, was used off of the model's left shoulder and bounced onto a large white scrim to soften it. The second fill created the shape and contour on the model's seamless "tube"; by shooting it into the scrim, I could control the amount

of shadow and the amount of wrap it had on the oval shape. One silver reflector was used from below for fill and catchlights. A gridded light was used on the background.

USE	Contest entry/advertising
CAMERA	Phase One P25, Hasselblad H2
FORMAT	Medium format digital
LOCATION	St. Petersburg, FL
LIGHTING	Studio strobes

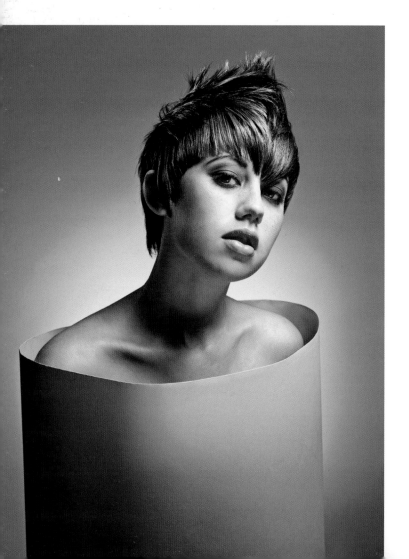

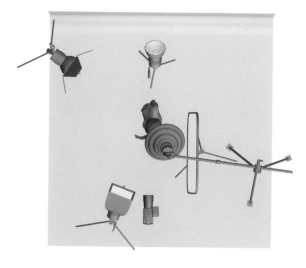

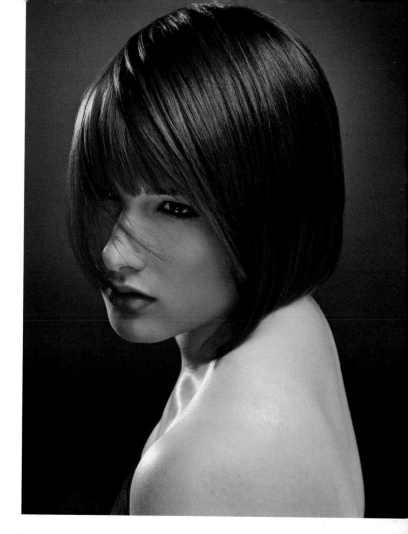

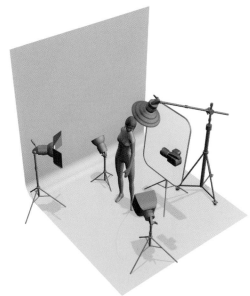

37| THE SCOOP

When creating beauty images for the hair industry, you light for the hair color and texture first, and for the model's face second. This can be new for a portrait photographer used to lighting primarily for the face.

TECH

A beauty dish was used overhead to bring out crisp details and the snappy color of the hair. A softbox was positioned from below as fill and to light the model's face. A rim light to the side (with barn doors) brought some added interest to the image, while a background light on a floor stand helped to separate the model from the background. One reflector was used camera right to add a touch of fill light.

TIP

The shine line on the hair is often important for creating shape and definition. To get it in the proper place, it is necessary to light from a more overhead angle than would be typical when photographing a person. With some hair styles, without the addition of a second light or reflector to add light to the face, the eyes will go dark because of the fringe of the hair. In this case, more light was needed than even a silver reflector would have offered; that is why a softbox was chosen. Careful balancing of the two lights was needed to achieve a somewhat convincing look.

CAMERA	Hasselblad H2 with Phase One P45+
FORMAT	Digital
LENS	Hasselblad 50-110mm f/3.5-4.5
FOCAL LENGTH	110mm
ISO	50
EXPOSURE	$^1/_{160}$ second at f/20
WHITE BALANCE	Custom
LOCATION	Houston, TX

38 | THE SCOOP

When photographing models for hair or beauty advertising, the effect of our lighting often makes us feel like product photographers. This is because, essentially, the hair is the product we are selling and the model is there as a prop. In these instances, it is just as important to light the hair as it is to light the model's face in the most flattering way possible. Keeping your main light simple and only adding light where it is needed is a good way to avoid confusing the elements of focus in your image.

TECH

In this photograph, I needed to emphasize the color of the hair and maintain its fine, detailed texture. The beauty dish did a great job of illuminating the top and front of the hair, while the hard side lights maintained an even illumination around the sides and kept the details discernible to the eye.

TIP

When it comes to posing, I like my beauty models to appear statuesque and carry a certain confidence. Shooting from a low camera angle can add length to a model's stature and give her a feeling of boldness and strength. I frequently photograph my subjects—everyone from models to children—in this way. It is not uncommon to see me lying on the ground, shooting up at a subject.

USE	Contest entry/advertising
CAMERA	Phase One P21
FORMAT	Digital
LENS	50–110mm f/3.5–4.5
FOCAL LENGTH	110mm
ISO	100
EXPOSURE	$^1/_{125}$ second at f/16
WHITE BALANCE	Custom
LOCATION	St. Petersburg, FL
LIGHTING	Studio strobes

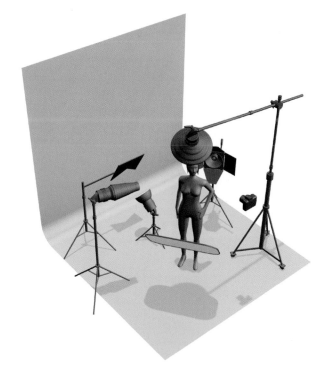

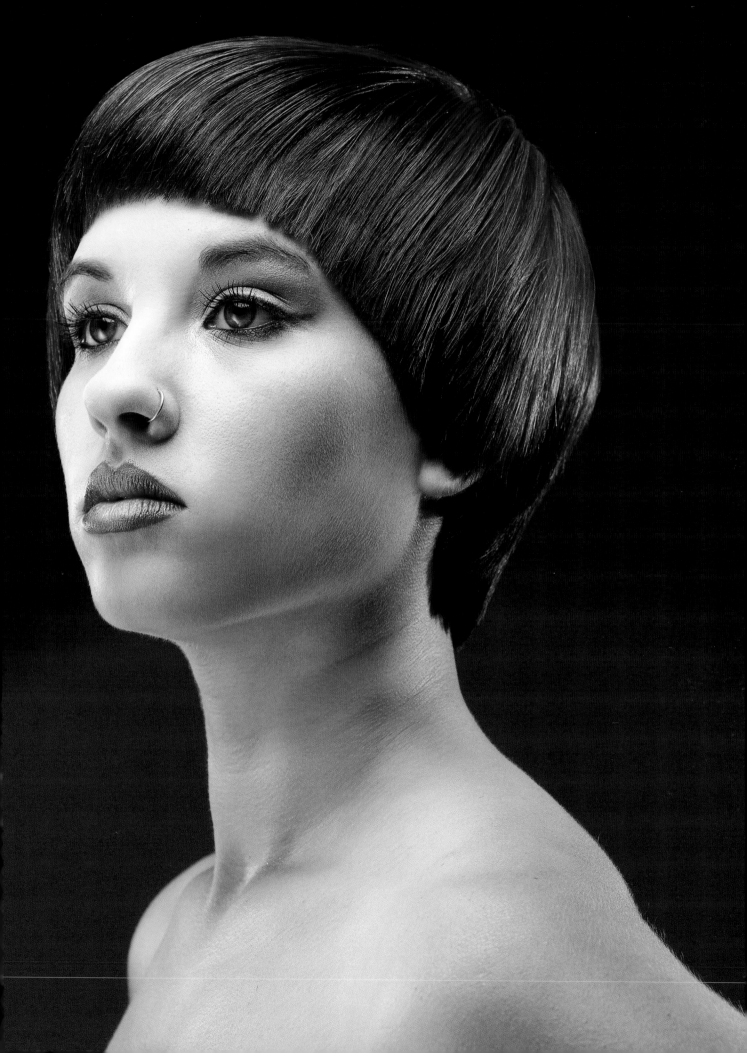

39 | THE SCOOP

Sometimes, lights can be used to add more interest to an environment as well as to control what commands the viewer's attention. The light inside the gallery was very flat, and emphasis needed to be placed on the piece of artwork my subject had created. I chose to use the contrast created by the lighting to define the focal points of the image.

TECH

To create a more impactful image, a shutter speed was chosen that would essentially eliminate the effects of the ambient light in the gallery. This way, the drama could be created using the strobes. I used one monohead fitted with standard reflector for the main light. This created deep shadows and textures. A small electronic flash was positioned on a bench behind my subject to create edge light. Additionally, a larger electronic unit was positioned

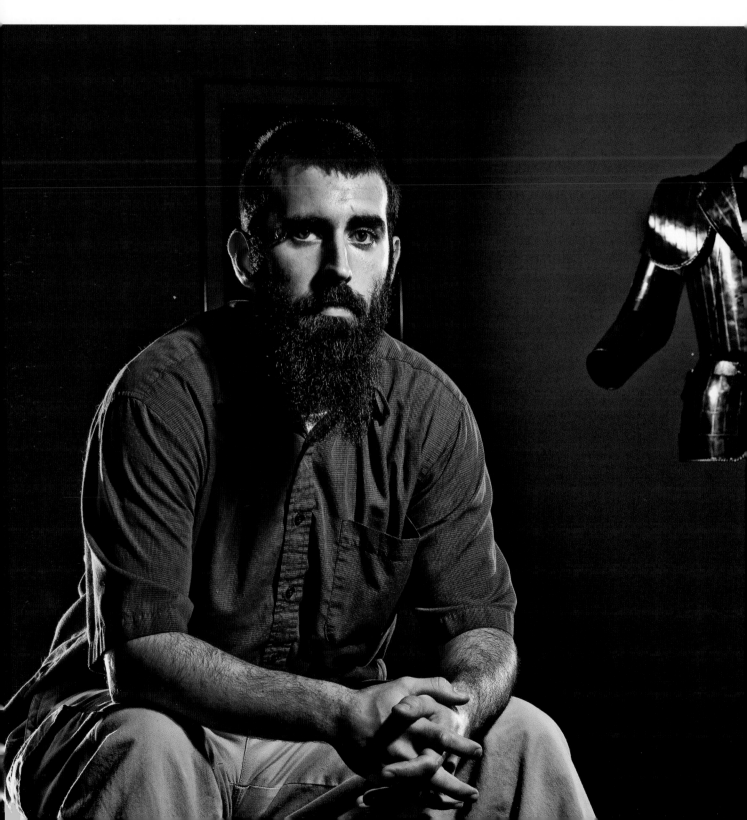

on a stand out of frame behind my subject at camera left to create the oval splash of light on the back wall. I selected a lens that would allow the piece of art in the background to go out of focus, keeping the emphasis on my subject.

TIP

Combining a higher power monohead with smaller electronic flash units is great choice—as long as you stay within the power capabilities of the electronic units.

USE	Editorial
CAMERA	Nikon D2Xs
FORMAT	35mm digital
LENS	70–200mm f/2.8
FOCAL LENGTH	98mm
ISO	100
EXPOSURE	$^1/_{125}$ second at f/14
WHITE BALANCE	Custom
LOCATION	Baton Rouge, LA
LIGHTING	Studio strobes
	Portable flash units

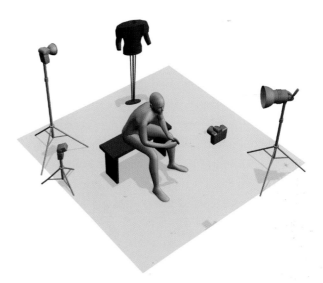

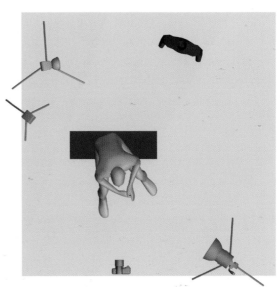

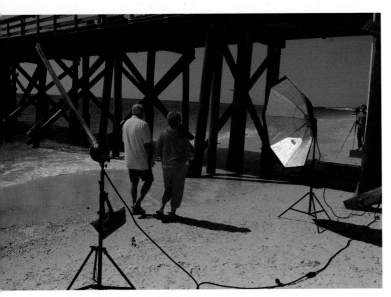

Photograph by Nabil Ashi.

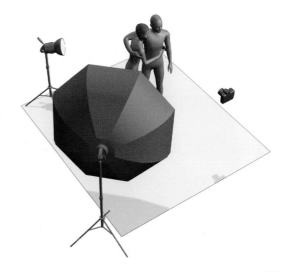

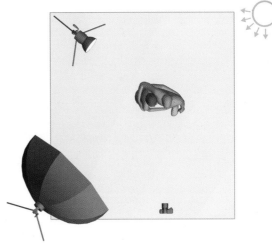

40 | THE SCOOP

When creating lifestyle images for advertising campaigns using non-professionals as models, it always helps to have sincerely happy people. After working with this couple for five to ten minutes on the beach, they were still a little reserved and stiff in front of the camera, so I asked them to give each other a big kiss—they did, and this was the moment right after. Sometimes, it is just matter of finding what breaks the ice and loosens people up. This time it was a simple kiss.

TECH

The goal of this lighting setup was for it to appear very natural. I used a five-foot Octabank with no inner or outer baffle for the main light. Another light with a standard reflector was placed behind the couple out of frame. The main light was metered so as to not overpower the sunlight; the result is a believable yet punchy image.

TIP

Shooting tethered on the beach was no small feat. My assistant and I had to bring all of the equipment from a walkway a hundred yards away from the shoot site by hand, because the rolling cart we were using would not budge on the sand. However, the advantage of having our art director review the images as they were captured was worth the effort.

USE	Advertising campaign
CAMERA	Nikon D3
	Tethered
FORMAT	35mm digital
LENS	70–200mm f/2.8
FOCAL LENGTH	155mm
ISO	200
EXPOSURE	$1/100$ second at f/18
WHITE BALANCE	Custom
LOCATION	Panama City, FL
TIME OF DAY	2:00PM
LIGHTING	Portable battery-powered strobes

USE	Promotion
CAMERA	Nikon D2Xs
FORMAT	Digital
LENS	17–35mm f/2.8
FOCAL LENGTH	35mm
ISO	400
EXPOSURE	$^1/_{125}$ second at f/9
WHITE BALANCE	Custom
LOCATION	Baton Rouge, LA
LIGHTING	Studio strobes

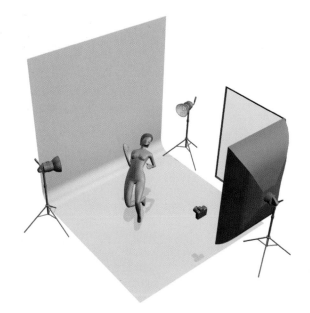

41 | THE SCOOP

Some of the best experiences as a photographer come when collaborating with other artists. Working with dancers is no exception. They are so conscious of their movement and the position of their bodies in action that it guarantees a beautiful image.

TECH

To create this image, two 4x6-foot softboxes were used at corners of the set. To achieve a very short flash duration, I dialed the pack down to a low setting. I adjusted for this loss of illumination by increasing the ISO of my camera to 400. (I generally hesitate to go above 400, because I want to eliminate as much grain or digital noise from the image as possible.) The model was backlit with two gridded lights at the edge of the seamless paper, one on either side.

TIP

When I photograph dancers, I like to stop motion. I find it fascinating to see still frames, frozen in time, of movements that otherwise pass so quickly before our eyes. Certain equipment selections have to be made to achieve these results. Some lights have very fast flash duration (the flash tube itself stays illuminated for a short duration during each firing). This speed eliminates any streaking or blurring in the captured image— because, essentially, the light is doing the work of your shutter. Most strobe packs offer their shortest flash duration when at low power settings, then grow longer as the power is increased.

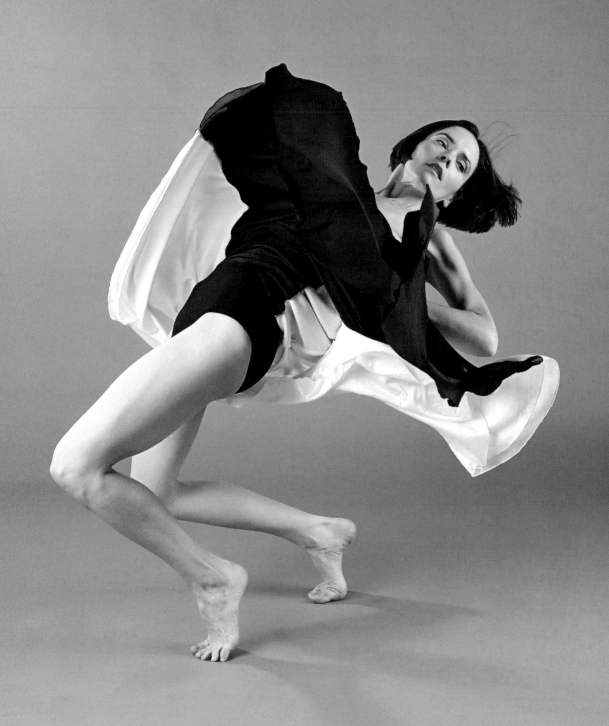

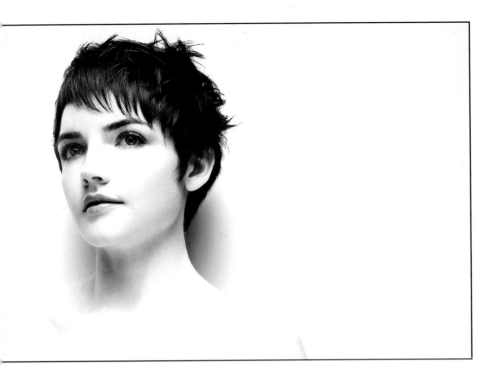

USE	Advertising
CAMERA	Nikon D2Xs
FORMAT	Digital
LENS	35–70mm f/2.8
FOCAL LENGTH	44mm
ISO	100
EXPOSURE	$^1/_{125}$ second at f/22
WHITE BALANCE	Custom
LOCATION	Baton Rouge, LA

42| THE SCOOP

It is possible to create beautiful work in very small spaces with minimal lighting. This image was produced as part of an advertising series for a hair salon. The art director wanted a strong series of black & white images to use as in-store art. I decided to go with a stark, high-contrast look, where the model seems to emerge from the white background. To do this, I positioned the model directly against a white wall.

TECH

A single beauty dish was used overhead with one silver reflector at around chest high. The drop shadows this created provided three-dimensional qualities that help the overall shape of the image. Digital image processing added to the minimalist high-key look.

With the use of a relatively short lens and a previsualized image concept that incorporated the background, only a small amount of space—no more than seven square feet—was needed to achieve the desired look.

USE	Private commission
CAMERA	Nikon D2Xs
FORMAT	Digital
LENS	35–70mm f/2.8
FOCAL LENGTH	52mm
ISO	100
EXPOSURE	$^1/_{125}$ second at f/13
WHITE BALANCE	Custom (user-defined)
LOCATION	Baton Rouge, LA
LIGHTING	Studio strobes

43| THE SCOOP

This is an example of how lighting techniques and concepts can remain similar even when the subjects themselves are very different. This lighting scenario could be used for any number of subjects—from a beauty shot, to an editorial image for a magazine, to (as here) a portrait of a small child. It is easy to overthink lighting and get stuck in habits that dictate what tools you use in your photography. Using unconventional instruments can make your work stand out from the crowd.

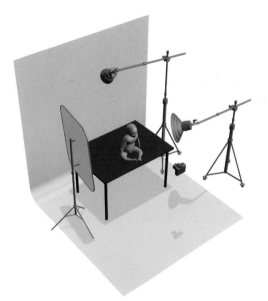

TECH

Here, a 27-inch Mola beauty dish was used to capture the direct gaze of the child. Given the size difference between a child and an adult, this light was the equivalent of a four- or five-foot light. This makes for a very soft, wrap-around quality in the light. A cross-processed effect was used on this image to emphasize the blue of the child's eyes and clothing.

TIP

I often use a five-foot-square table to create a miniature cyclorama for my tiny models. Getting children up off of the floor can make photographing and lighting them much easier.

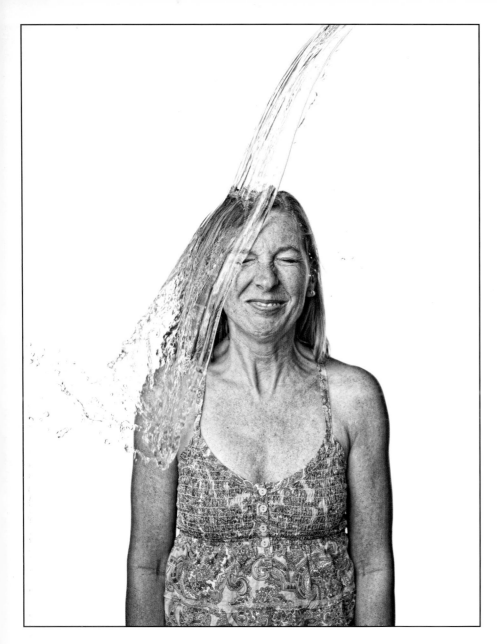

USE	Personal project
CAMERA	Phase One P45+
	Phase One 645
	Tethered
FORMAT	Medium format digital
LENS	80mm f/2.8
FOCAL LENGTH	80mm
ISO	100
EXPOSURE	$1/100$ second at f/3.2
WHITE BALANCE	Custom
LOCATION	Long Beach, CA
LIGHTING	Studio strobes

44 AND 45 | THE SCOOP

These images were part of a personal project where the intent was to capture the action and expression of my subjects as they had water poured over their heads. I chose lights that had an extremely short flash duration to stop the quick motion of the water pouring and freeze the subjects' reactions as they flinched from the cold water.

TECH

The strobes that were chosen have a flash duration of $1/12,000$ second but only at their lowest power setting. The low power setting on the lights also resulted in a very low aperture setting on the camera, so focusing was critical. I mounted the camera on a tripod and had each subject stand in a fixed spot. To check the focus, I took an initial portrait of the subject and reviewed it on the computer monitor. The extremely shallow depth of field caused some missed frames when the subjects shifted forward or backward—but the few lost frames were worth the resulting modern look of the final images.

The lighting for these images was simple but well thought out. I knew that I wanted a broad light to get a nice, bright, high-key look. I also needed a somewhat hard light to make sure that there was detail in the water. Because of the splashing water, the lights could not be positioned too close to the subject, so a large five-foot umbrella was selected as the main light. Another light was used directly behind the model to light the background.

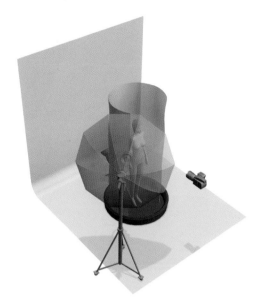

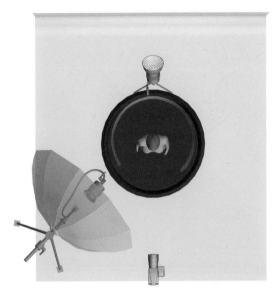

Careful metering was needed to ensure that the background light did not blow out the detail on the pouring water.

The original sketch of my lighting setup included two side lights to achieve the edge highlights on the subjects' faces. However, as we tested the lighting scenario we found that, because of the light bouncing off of the plastic we used to protect the studio from water, additional side lights weren't needed.

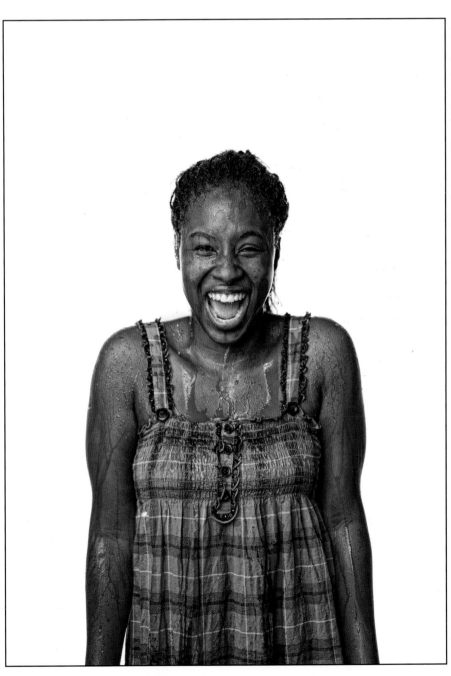

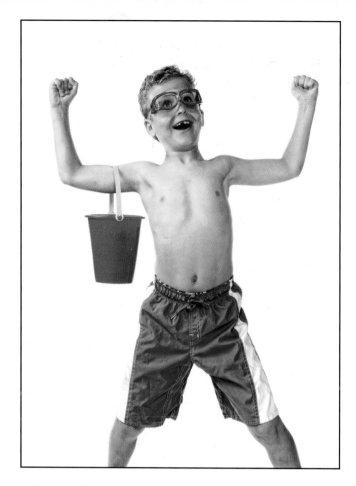

USE	Promotional materials
CAMERA	Nikon D2Xs
FORMAT	35mm digital
LENS	17–35mm f/2.8
FOCAL LENGTH	17mm
ISO	100
EXPOSURE	$^1/_{160}$ second at f/10
WHITE BALANCE	Custom
LOCATION	Baton Rouge, LA
LIGHTING	Studio strobes

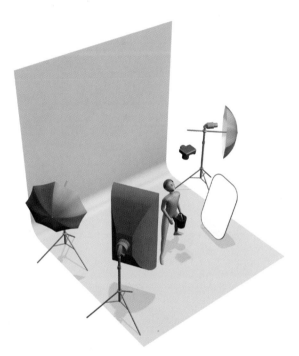

46 AND 47 | THE SCOOP

Working with children for advertising assignments can be as rewarding as it is daunting. Children have a unique way of being surprisingly easy to work with at times, but photographers must realize thay they are also one tantrum away from the session being ended. This assignment required the use of props for the children to use in the images. This was a bit out of character for me (I usually do not use props when I do commissioned portraits), but in this case the props were needed to express what my client was trying to say.

TECH

A relatively simple high-key setup was used for this series of images. A 2x4-foot softbox was used as the main light and a reflector was use at my subject's left for fill. Two umbrellas were used to light the background and an overhead light, fitted with a standard reflector, was used to help blow out the floor. This also added some edge and detail highlights on the model. For this image, I shot down from a ladder with a wide-angle lens to add a dramatic, exaggerated look.

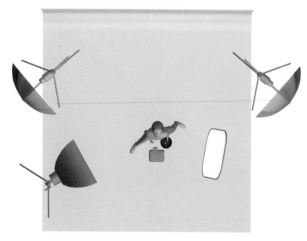

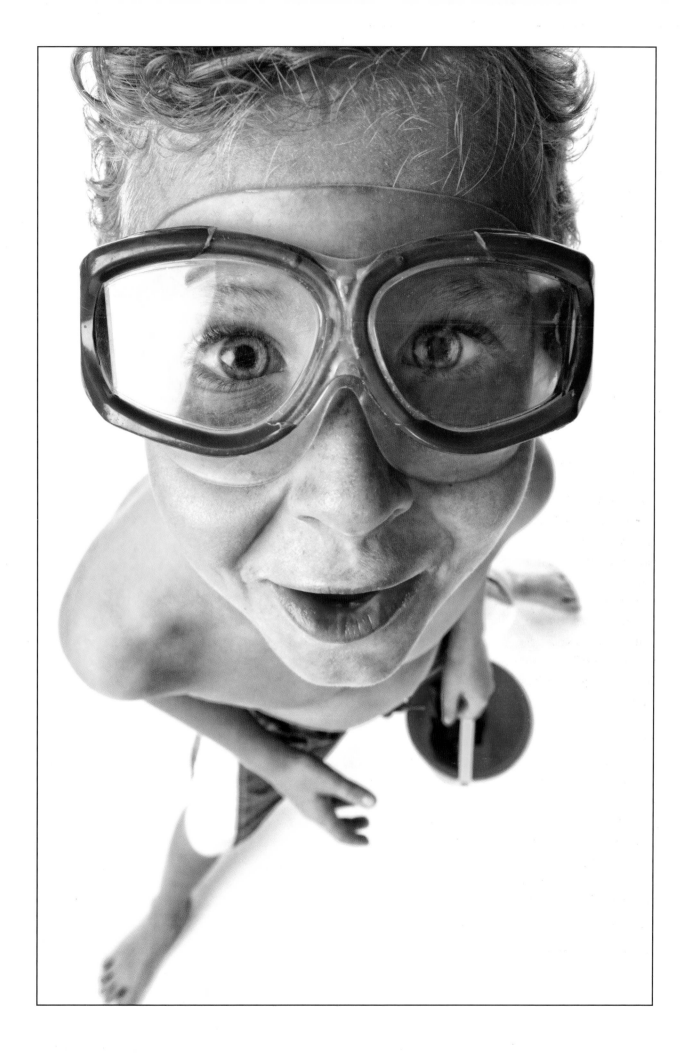

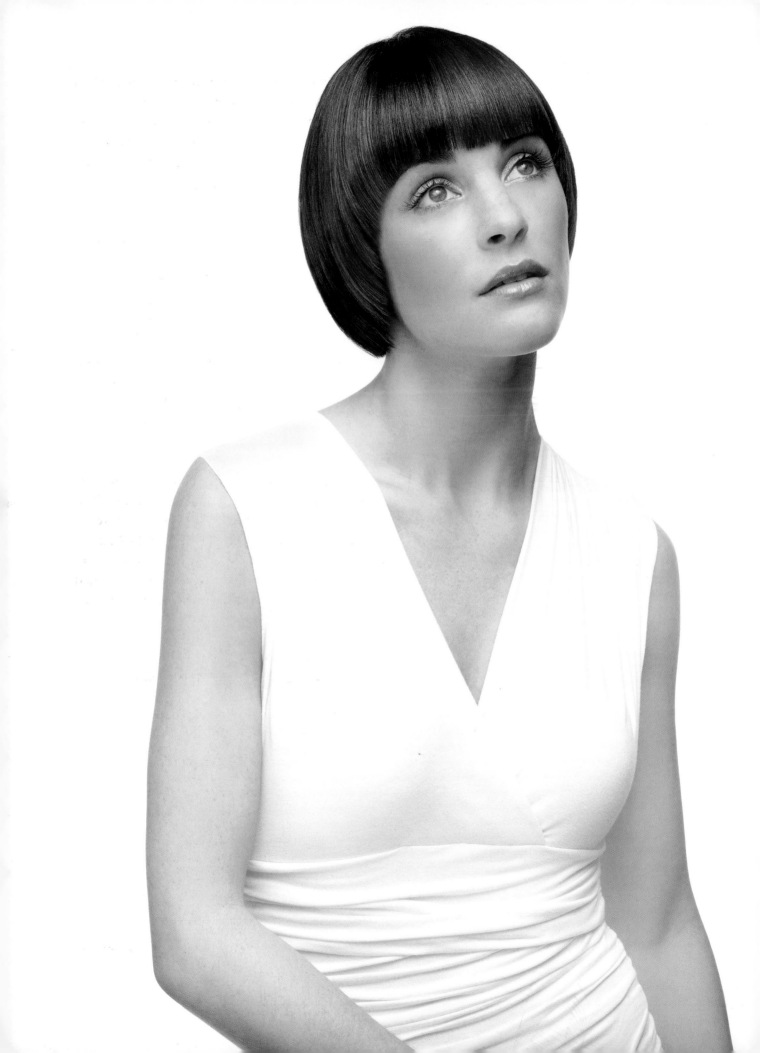

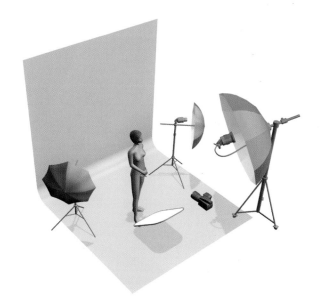

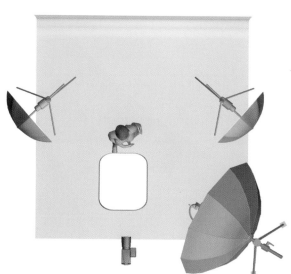

48 | THE SCOOP

This advertising campaign was designed to sell a salon's hair-color services. The images were to have as much emphasis on the hair color as possible. To do this, specific clothing and makeup choices were made to ensure the images appeared nearly monochromatic, drawing attention to the hair.

TECH

To keep the image clean and put focus on the hair color, I chose to create a high-key image. To get the softest white lighting, I used a five-foot Giant Reflector (from Profoto) with a diffuser. This light was placed as close as I could get it to the model and still keep it out of the frame. For most of the images, I had the camera pushed directly up next to the light. You can see the very large catchlights in her eyes. Two umbrellas were placed in the background to light the arctic white seamless paper. A silver reflector was used from below the lens to fill in any shadows.

TIP

The model's upward gaze eliminated any downward shadows on her face, exaggerating our peaceful washed-out look. Since the eye tends to be drawn to the extremes of an image, like the darkest areas or the brightest, it was my intent to keep the model's hair the darkest part of the frame. To do this, decisions were made that would eliminate any shadows and other dark areas in the frame.

USE	Advertising campaign
CAMERA	Phase One P45+, Hasselblad H2 Tethered
FORMAT	Medium format digital
LOCATION	Santa Barbara, CA
LIGHTING	Studio strobes

49 AND 50 | THE SCOOP

Knowing that these images were to be used in black & white, I chose to retain some information in the background instead of letting it go totally white. A very clean, white background works well for color images but in black & white it tends to distract from the subject because the viewer's gaze tends to go to the brightest or darkest part of a photo. In images like this, I like to try to have the subject's eyes be the whitest part of the image.

TECH

Using a beauty dish as the main light creates a crisp, modern take on a classic high-key portrait. Here, two umbrellas were used to light the background; these were positioned to let some of the light spill onto the subject, creating some rim lighting.

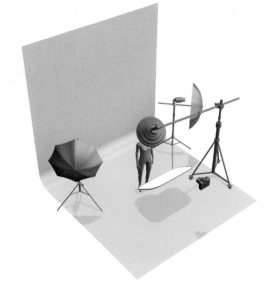

USE	Commissioned portrait
CAMERA	Nikon D2Xs
FORMAT	35mm digital
LENS	50mm f/1.8
FOCAL LENGTH	50mm
ISO	100
EXPOSURE	$^1/_{160}$ second at f/14
WHITE BALANCE	Custom (user-defined)
LOCATION	Baton Rouge, LA
TIME OF DAY	N/A
LIGHTING	Studio strobes

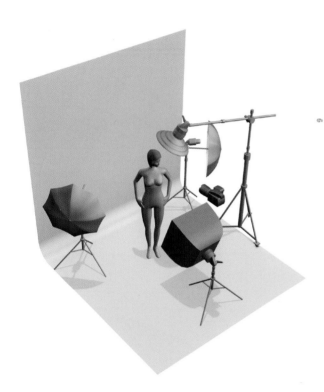

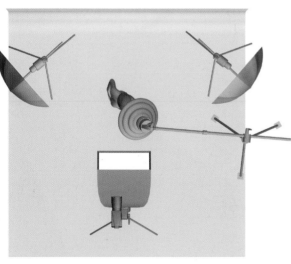

51 | THE SCOOP

This image was part of a series taken for a hairdresser's entry in a national hair competition. It is one shoot that reminded me the importance of professional models, a beautiful studio, and a great stylist team. All the factors came together at this shoot—and it was enough to spoil any photographer.

TECH

I built the lighting setup for this shoot around a simple butterfly lighting pattern, using a beauty dish overhead on a boom stand. For an extra punch of light, I substituted the usual fill reflector with a 2x2-foot softbox. You can see the resulting catchlights in the model's eyes. Two umbrellas were used to produce the high-key effect on the white cyclorama. One of the things I like about the high-key setup, combined with a model with short hair, is the natural rim light that grazes the side of the model's face.

USE	Hairdresser's contest entry
CAMERA	Phase One P45+, Hasselblad H2
FORMAT	Medium format digital
ISO	100
WHITE BALANCE	Custom
LOCATION	Miami, FL
LIGHTING	Studio strobes

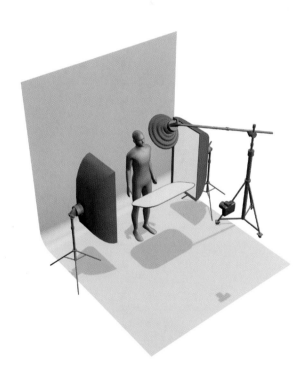

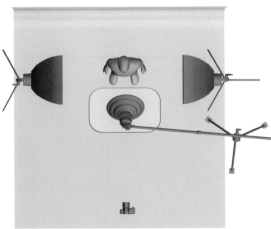

USE	Artist's promotion
CAMERA	Nikon D2Xs
FORMAT	Digital
LENS	35–70mm f/2.8
FOCAL LENGTH	32mm
ISO	100
EXPOSURE	$1/125$ second at f/9
WHITE BALANCE	Custom
LOCATION	Baton Rouge, LA
LIGHTING	Studio strobes

52| THE SCOOP

I was asked by photographer David Humphreys to photograph him for a promotional piece he was working on. David is a food photographer, so he was portraying himself as a chef. In the end, I liked the image so much that I used it in my own portfolio as well. The images were to be turned into an illustration and the piece was to be humorous, so I chose a short lens to make the image "cartoonish" and used very graphic lighting.

TECH

A Mola beauty dish was selected as the main light to maintain the overall crisp details. One softbox was placed on either side for an even rim light. The monochromatic tones between the background and David's clothing draw the viewer's focus to his face. The vignette was added in postproduction. A silver reflector was used from below David's chin for additional fill.

53 | THE SCOOP

Photographing children is always a display of unguarded emotions. It can be the easiest, most rewarding experience a photographer can have, or it can be a difficult, frustrating event. Staying with simple lighting and uncomplicated sets can help make the experience stress-free for both the photographer and child. I try to light the entire set as a whole so that children have the ability to move freely without having to remain in one critical spot.

TECH

For this image, I used a Mola beauty dish on a boom only about 2.5 feet off of the ground. I positioned a four-foot reflector under the light, angling it upward for a bit of fill. Two lights on stands were placed in the background, fitted with standard reflectors, and metered one stop over my main light.

TIP

I feel it is very important, when working with children, for the lighting and photographer to be at the level of the child. I am frequently lying on my stomach or sitting on the floor so that I can talk to my subject face to face and keep the perspective of the image at his eye level—or even lower.

USE	Private commission
CAMERA	Nikon D2Xs
FORMAT	35mm digital
LENS	35–70mm f/2.8
FOCAL LENGTH	52mm
ISO	100
EXPOSURE	$^1\!/_{125}$ second at f/14
WHITE BALANCE	Custom
LOCATION	Baton Rouge, LA
LIGHTING	Studio strobes

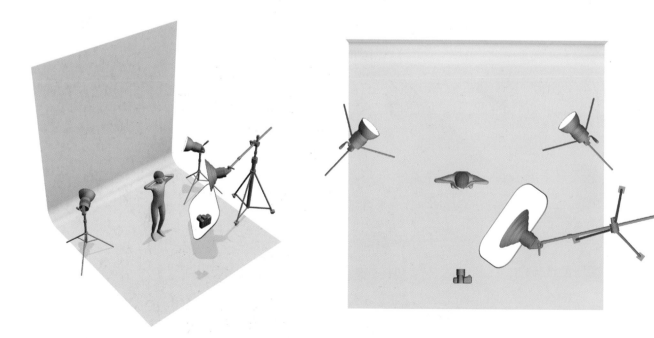

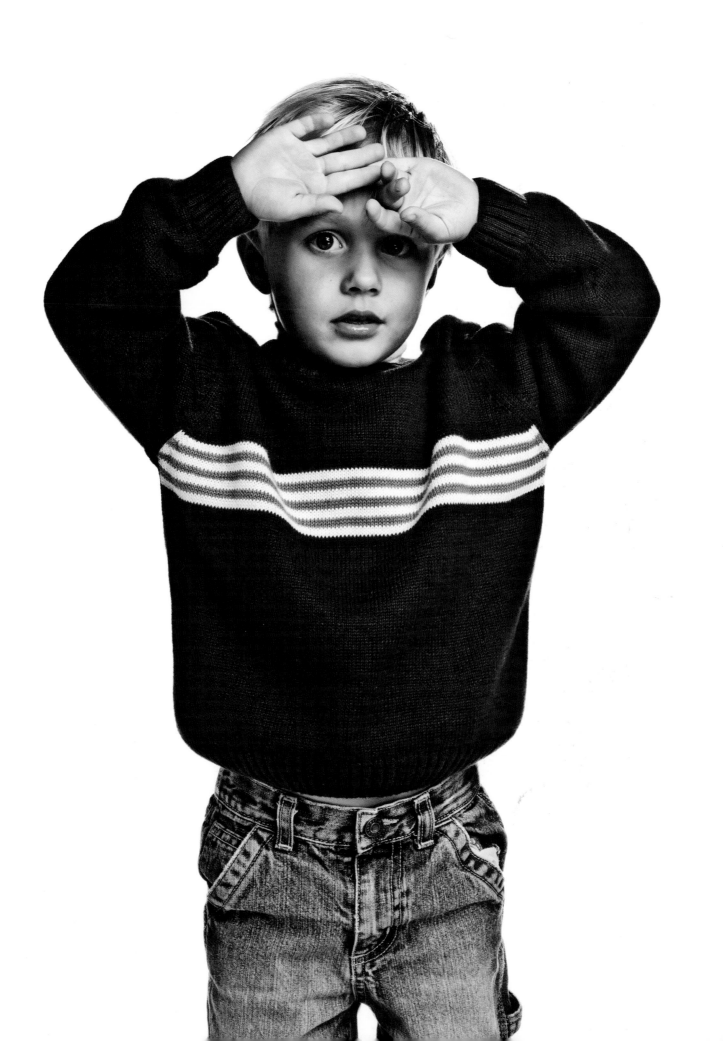

54| THE SCOOP

While photographing a series of advertising images for a salon, I noticed the strong graphic shape of the model in profile. To accent the shape, I turned off my main light and photographed the model in silhouette. I used Photoshop to copy and paste the model, creating a mirage of sorts. The subtle light spilling from the background across the model's chest adds a three-dimensional aspect to an otherwise one-dimensional image.

TECH

Don't be afraid to play a little during a photo shoot—but remember that there is a difference between fumbling around, randomly trying things without foreseeable outcomes and doing deliberate experiments with reproducible results. This is where testing your lights and knowing exactly what you can expect will not only lead to great images but also make you appear highly skilled in your client's eyes.

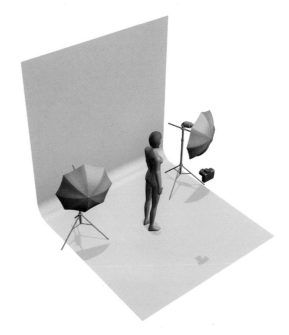

USE	Advertising
CAMERA	Nikon D2Xs
FORMAT	Digital
LENS	35–70mm f/2.8
FOCAL LENGTH	40mm
ISO	100
EXPOSURE	$^1/_{125}$ second at f/18
WHITE BALANCE	Custom (user-defined)
LOCATION	Baton Rouge, LA
LIGHTING	Studio strobes

55 | THE SCOOP

The use of a ring flash alone can create a youthful look in an image. When I use a ring flash, I like to get my subjects standing up, moving around, and really emoting. I frequently turn on a fan and have the model playing and doing fun poses; I feel this lends itself to the look of the lighting. I also like to use monochromatic styling and to coordinate the background color with the clothing color that the model has on.

TECH

A single ring flash was used to create this image. The camera and light were mounted on a tripod so that the light would not move closer to the model. The model was positioned very close to the background to allow for the shadow halo to be well-defined.

USE	Private commission
CAMERA	Nikon D2X
FORMAT	35mm digital
LENS	70–200mm f/2.8
FOCAL LENGTH	17mm
ISO	100
EXPOSURE	$\frac{1}{80}$ second at f/13
WHITE BALANCE	Custom
LOCATION	Baton Rouge, LA
LIGHTING	Ring flash

56| THE SCOOP

Posing models for hair photography can be tricky—especially when you are not working with professionals. Hair shoots can be particularly trying for both the photographer and the model because the position of the hair has to be perfect. When the optimal angle of the hair and the model's face is found, the model has to hold that position while the hair is placed just right. At the same time, the model must appear relaxed and confident.

TECH

This image was created using a four-light setup. A beauty dish was positioned overhead to illuminate the hair, while a ring flash was used to wash out most of the shadows. A reflector was placed below the model, at waist height, as an additional fill source. A kicker fitted with barn doors was placed behind the model to the left. The background texture was created by shooting light onto seamless through a piece of cardboard that had flowing shapes cut into it. Using a long lens created the appearance of the blur on the background; the foreground blur was exaggerated in postproduction.

TIP

In my opinion, the ability to shoot tethered has facilitated the image-creation process and changed the interaction between the photographer and the art director in a way no other photographic advancement ever has. Being able to snap a shot and have it be instantly viewed on an HD Cinema display is an amazing creative tool.

USE	Competition entry/advertising
CAMERA	Phase One P45+, Phase One 645 Tethered
FORMAT	Medium format digital
LENS	110mm f/2.8
FOCAL LENGTH	110
ISO	50
EXPOSURE	$^{1}/_{160}$ second at f/20
WHITE BALANCE	Custom
LOCATION	Fort Lauderdale, FL
LIGHTING	Studio strobes

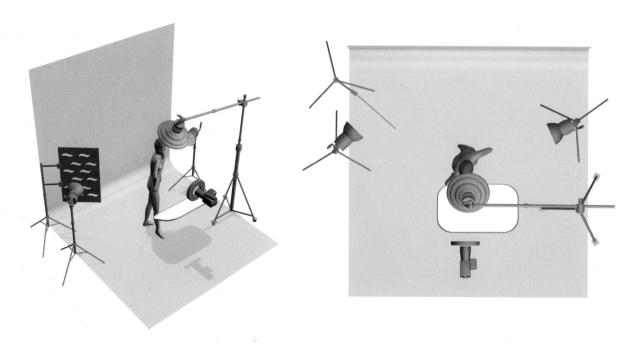

57| TECH

Like most of my beauty images, this image was lit with a simple beauty dish overhead to illuminate the hair. For an extra pop of detail and fill light, a ring flash was added. I used a background light to lessen the halo of shadows that are typical of ring flash and positioned gridded lights on either side of the model to eliminate edge shadows.

USE	Advertising
CAMERA	Nikon D2Xs
FORMAT	Digital
LENS	35–70mm f/2.8
FOCAL LENGTH	24mm
ISO	100
EXPOSURE	$^1/_{125}$ second at f/18
WHITE BALANCE	Custom
LOCATION	Baton Rouge, LA
LIGHTING	Studio strobes

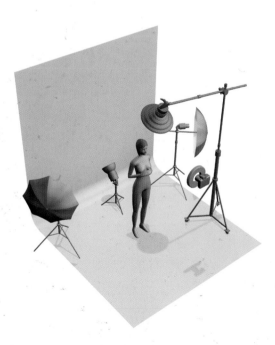

USE	Artist's portfolio
CAMERA	Nikon D2Xs
FORMAT	35mm digital
LENS	17–35mm f/2.8
FOCAL LENGTH	24mm
ISO	100
EXPOSURE	$^1/_{250}$ second at f/14
WHITE BALANCE	Custom
LOCATION	Baton Rouge, LA
LIGHTING	Studio strobes

58| THE SCOOP

Trying unconventional tools can make very unique images. Here, I experimented with a ring flash for dance photography, which was something I had never seen done. I was curious as to how the light would stop the motion and just how it would react with the model's skin and muscle definition as she moved.

TECH

A single ring flash was used to create this image. The flash was mounted on a stand, but I chose to handhold the camera. Looking through the small hole in the ring flash doesn't allow for much freedom or camera shift, but to photograph the dancer I was able to utilize these small movements to keep her in frame.

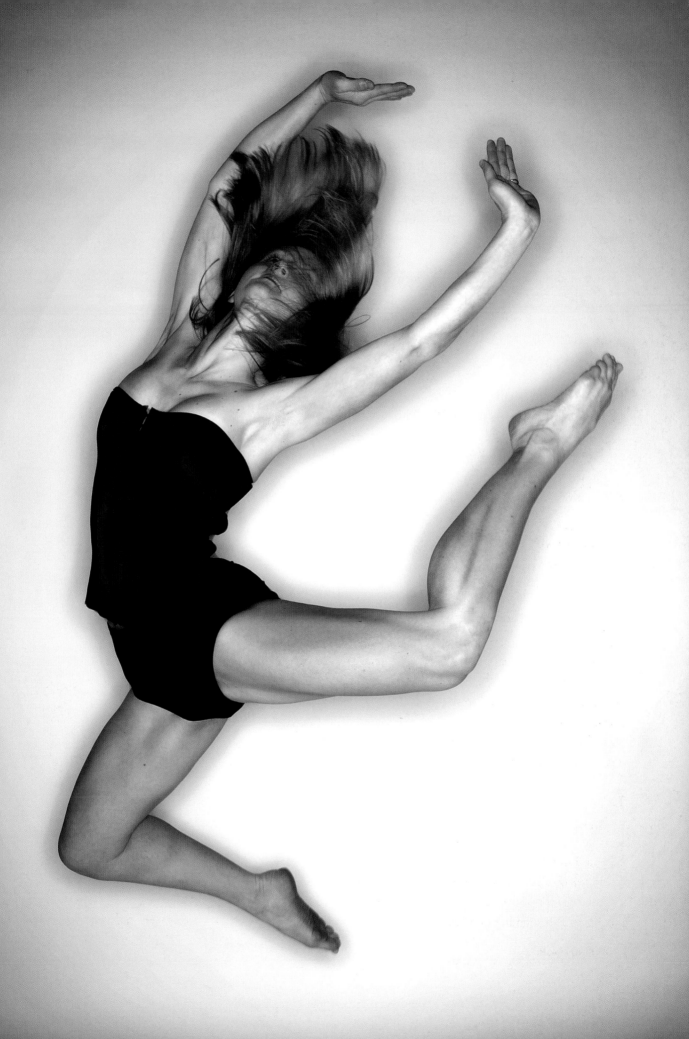

RESOURCES

CREW AND STYLISTS

www.photoassistant.net—A database for photographers and assistants that includes portfolios and bios.

www.modelmayhem.com—A database and social site for models and stylists.

www.workbook.com—Sourcebooks and website with comprehensive features and resources for finding talent and services.

www.hairbrained.me—A hairstylist database as well as a social networking site.

PROFESSIONAL ORGANIZATIONS

www.asmp.org—Trade association for photographers who photograph primarily for publication. ASMP promotes photographers' rights, educates photographers in better business practices, produces business publications for photographers, and helps buyers find professional photographers.

www.apanational.com—American Photographic Artist's goal is to establish, endorse, and promote professional practices, standards, and ethics in the photographic and advertising community.

www.ppa.com—Professional Photographers of America seeks to increase its members' business savvy as well as broaden their creative scope.

www.wppionline.com—Wedding and Portrait Photographers International is devoted solely to the special interests and needs of wedding photographers and portrait photographers.

EQUIPMENT RENTALS

www.calumetphoto.com

www.samys.com

www.borrowlenses.com

www.lensrentals.com

PHOTOGRAPHIC TRAINING

www.prophotoresource.com

SOFTWARE TRAINING

www.lynda.com—Software training video database.

www.napp.com—National Organization of Photoshop Professionals.

INDEX